SOLDIERS OF GLOUCESTERSHIRE IN 100 OBJECTS

CHRIS CHATTERTON

AMBERLEY

ABOUT THE AUTHOR

Chris Chatterton was a secondary school teacher in Gloucestershire for nearly a decade before being elected to Gloucester City Council. He served as Mayor of Gloucester in 2013–14 and became Museum Director of the Soldiers of Gloucestershire Museum in 2014.

First published 2017

Amberley Publishing
The Hill, Stroud
Gloucestershire, GL5 4EP

www.amberley-books.com

Copyright © Chris Chatterton, 2017

The right of Chris Chatterton to be identified as the Author of this work has been asserted in accordance with the Copyrights, Designs and Patents Act 1988.

ISBN 978 1 4456 7690 6 (print)
ISBN 978 1 4456 7691 3 (ebook)

British Library Cataloguing in Publication Data. A catalogue record for this book is available from the British Library.

Origination by Amberley Publishing.
Printed in the UK.

INTRODUCTION

The Soldiers of Gloucestershire Museum, located in Gloucester's historic docks, has existed in one form or another for over a century. It exists to tell the stories of those soldiers who have served and fought under the banner of Gloucestershire for thirteen generations and to act as a memorial to those who have given their lives for their country since 1694. While the names may change, the role hasn't, and the museum seeks to articulate these stories for future generations. With a collection of nearly 20,000 objects and tens of thousands of images, it is impossible to tell everything in a publication such as this. These 100 objects and images have been selected to provide a flavour, an insight into what the museum does and the story we tell. Some of the objects are very common and familiar, others unique, but they all contribute to our past, to the unique role played by soldiers from Gloucestershire in actions from Quebec to Korea, from Alexandria to Afghanistan. Our predecessors have played a significant role in changing history for three centuries. This book is an introduction to our story, to our collection and to our people, and we hope you come and visit and see more of what we offer.

The Soldiers of Gloucestershire Museum
Gloucester Docks
www.soldiersofglos.com

SOLDIERS OF GLOUCESTERSHIRE IN 100 OBJECTS

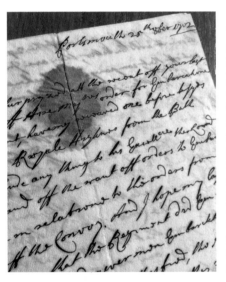

The Gloucestershire Regiment begins its long and distinguished story in 1694, when a new Regiment of Infantry was raised by Colonel John Gibson. Until the middle of the eighteenth century, regiments were the property of their colonels, and the new regiment was therefore known as Gibson's Regiment of Foot. The regiment was first sent to Newfoundland to protect British settlers from the French, and they suffered appalling casualties, mainly from disease and exposure to the bitter winter. One of the earliest items in the museum collection is a handwritten letter from Col Gibson. This letter, dated 25 October 1702, concerns the inadequacy of the arrangements being made to move the regiment to Ireland and is the only object in the museum written in Gibson's hand.

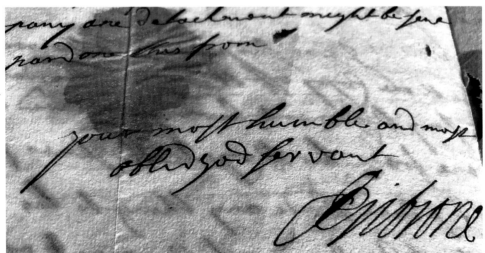

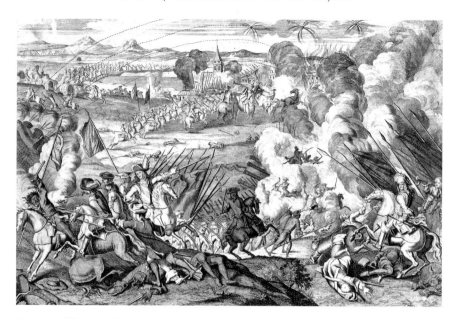

In 1704, Gibson sold the regiment to Colonel de Lalo, who would gain the first of an unprecedented number of Battle Honours. In 1705, De Lalo joined the forces of the Duke of Marlborough during the War of the Spanish Succession and the following year fought with much spirit at the Battle of Ramillies, as seen in this engraving of the battle scene that was reproduced across the whole country to celebrate Marlborough's successes against the French.

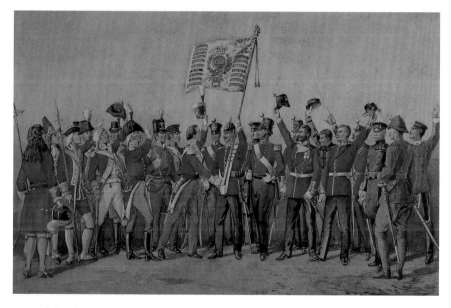

One of the things that most vividly shows the changes and developments in the Army is the way in which uniforms changed over time. This painting by Lt Col Lovett in 1910 demonstrates these changes and shows the history of officers' uniforms from 1694 to 1910. As you can see, contemporary fashions rather than practicalities were the prime mover, a situation that would finally end with the conflicts of the twentieth century.

A PROCLAMATION

HIS Majesty has been graciously pleased to signify that he has nothing more at Heart then to repair the Losses and Disappointments of the last inactive and unhappy Campaign, and by vigorus and extensive Efforts, to avert, by the blessing of GOD on his Arms, the Dangers impending on North-America, and not doubting but all his faithful and brave Subjects here, will cheerfully co-operate with, and second to the utmost, the large Expence, and extrordinary Succours, supplied by the Kingdom of Great-Britain, for their Provinces of the Massachsetts-Bay, New-Hampshire, Rhode-Island, Connecticut, New-York, and New-Jersey, are of themselves, well able to furnish at least, *TWENTY THOUSAND* Men, to join A Body of the *KING*'s Forces for invading Canada, and carrying War into the Heart of the Enemy's Possessions.

For promoting this great and important End, it is hereby published and made known, that every able-bodied effective Man that shall voluntary inlist in one of the Regiments, ordered to be raised for the Purpose aforesaid, and shall furnish himslef with suitable Clothes, a Powder-Horn, and Shot-Bag, as aforesaid, he is to be supplied with the Same by his Captain out of the aforesaid Bounty, and the Remainder (if any be) to be paid him.

And that the Wages for this Service per month, accounting Twenty-eight Days to a Month, are for a Serjeant, a Clerk, and a Drum-Major, each Two Pounds; for a Drummer, and a Corporal, each One Pound eighteen Shillings; and for a private Soldier, One Pound sixteen shillings. And they are to be furnished by the *KING*, with Arms, Ammunition and Tents, and to have Provisions in the same Proportion and Manner as the rest the *KING*'s Forces; prior to which, if they subsist themselves, they are to receive from the Time of Inlistment, the *KING*'s Allowance in Money. These Encouragements being so many and great, it is hoped every one will be roused and excited, with Zeal to promote this important Undertaking, and that a sufficient Number of Able Men will enter into this Service, for the Preservation and Defence of their Country, and especially as ther appears a reasonable Prospect, by the Blessing of GOD on our Endeavours, of a happy Success.

> *GIVEN on this Fifteenth Day of April, in the Thirty-first year of the Reign of our Soverign Lord GEORGE the Second, of Great-Britain, France and Ireland, KING, Defender of the Faith, &c.*

GOD SAVE THE KING

HIS Majefty has been gracioufly pleafed to fignify that he has nothing more at Heart then to repair the Loffes and Difapointments of the laft inactive and unhappy Campaign, and by vigorus and extenfive Efforts, to avert, by the bleffing of GOD on his Arms, the Dangers impending on North-America, and not doubting but all his faithful and brave Subjects here, will cheerfully co-operate with, and fecond to the utmoft, the large Expence, and extrordinary Succours, fupplied by the Kingdom of Great-Britain, for their Provinces of the Maffachfets-Bay, New-Hampfbire, Rhode-Ifland, Connecticut, New-York, and New-Jerfey, are of themfelves, well able to furnifh at leaft, TWENTY THOUSAND Men, to join A Body of the KING's Forces for invading Canada, and carrying War into the Heart of the Enemy's Poffeffions.

Above and opposite: By the mid-eighteenth century, Britain was locked in conflict with France over territory in North America. Pictured here is a proclamation issued by George II to the colonists in 'the Provinces of Massachsess-Bay, New Hampshire, Rhode Island, Connecticut, New-York and New-Jersey' to provide a force of 20,000 men for the purpose of 'invading Canada and carrying War into the heart of the Enemy's Possessions'. These soldiers would provide most of their own equipment but would be furnished by the King with arms and ammunition.

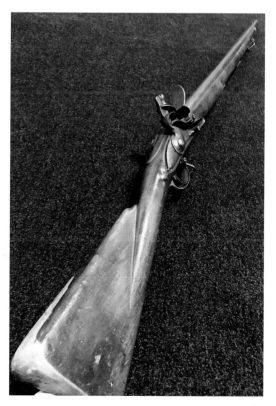

The weapon that they would have used was the Long Land Pattern musket, more commonly known as the 'Brown Bess'. This weapon, a .75-caliber flintlock musket, was the standard long gun of the British Army from 1722 until 1838, and had an effective range of 175 yards, although it would generally be fired *en masse* at 50 yards. It weighed about 10lb (4.5kg) and could be fitted with a 17-inch bayonet. It would be deployed to devastating effect in the forthcoming conflict in Canada.

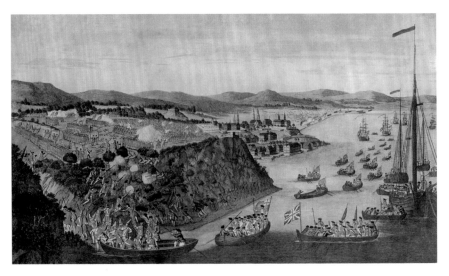

Above, below and opposite above: In 1757, the regiment, now known as the 28th Regiment of Foot after a reorganisation of the Army, set sail for Canada to join the forces of the colonists. After capturing Louisburg in Nova Scotia, they were placed in the centre of General Wolfe's forces for the assault on Quebec. They climbed the Heights of Abraham using a narrow and steep path and positioned themselves to the west of the city. The French attacked with supporting artillery fire, but the British forces, with the 28th at the centre, stood firm and silent until the French were only 35 paces away. They then opened fire. The hail of shot shattered the advancing troops, who turned and ran, only to be pursued by the British with sword and bayonet. The city surrendered a few days later, although General Wolfe was killed in the fighting. The capture of Quebec was a key milestone in the defeat of the French in Canada, and is portrayed in this illustration. The victory was also commemorated in the production of a special medallion.

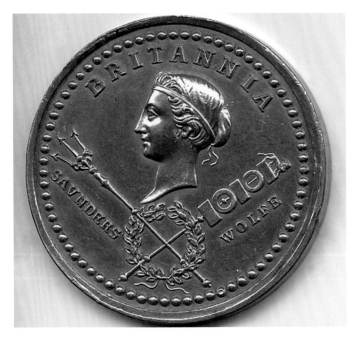

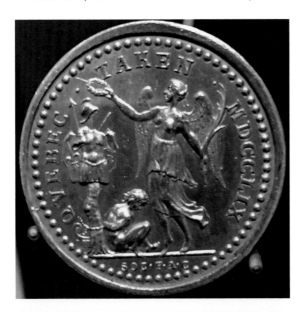

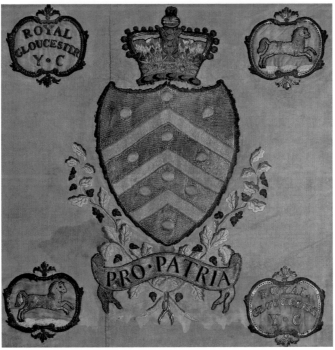

One of the most important symbols of a regiment or military unit are the colours that they carry. These were originally used to mark the location of the commander and to act as a rallying point for troops in a battle and are thought to date back to Ancient Egypt. The Colours are treated with great reverence and the museum is fortunate to possess a significant number covering large parts of our histories. Shown here is the Royal Gloucestershire Yeomanry Cavalry Standard, as used by the City of Gloucester Troop in 1797. As can be seen, the centre of the standard incorporates part of the coat of arms of the city of Gloucester.

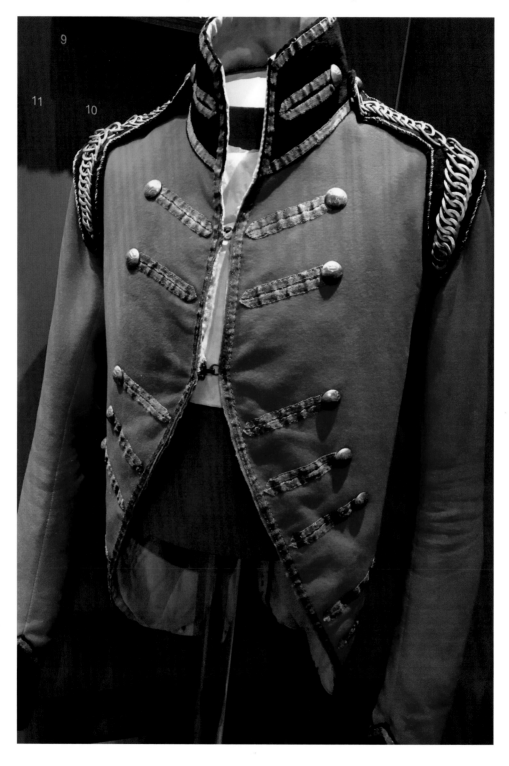

Above, right and opposite:
Uniform was also a key part of
a regiment's identity and would
differ slightly from unit to unit.
This jacket is one of the many
uniforms housed in the museum
collection and is an officer's jacket
dating from 1795. This jacket was
worn by an officer in the Royal
Gloucestershire Yeomanry Cavalry.
The second uniform (below) was
worn by a prive in the Bristol
Infantry Volunteers in 1792.

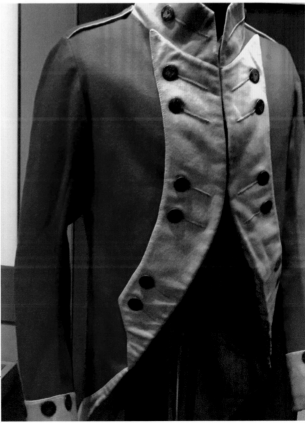

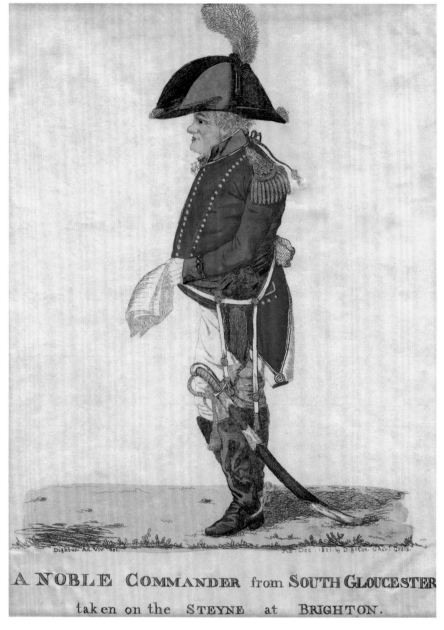

A NOBLE COMMANDER from SOUTH GLOUCESTER

taken on the STEYNE at BRIGHTON.

As well as regular Regiments of Foot, such as the 28th and the recently formed 61st, a number of militia regiments were founded and stationed on the south coast in order to free up regular troops for other duties. There was a perceived threat of invasion in the last years of the eighteenth and early years of the nineteenth century and for much of the Napoleonic Wars the Royal South Gloucestershire Militia were stationed in Brighton, where they attracted the attention of the Prince of Wales and earned the unofficial title of the 'Brighton Guards'. This illustration is a contemporary caricature of the 5th Earl of Berkeley, who commanded the Royal South Gloucestershire Militia between 1768 and 1810.

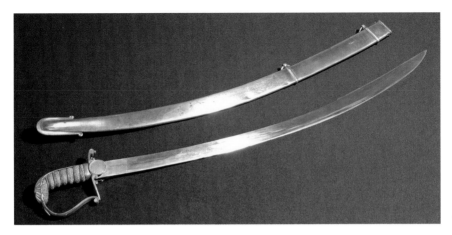

Here is a good example of one of the key weapons carried during the Napoleonic Wars. This Georgian Infantry Officer's sabre has a 79-cm blade, etched on each side with the number '28', signifying the regiment of the holder. This sabre was carried through the Napoleonic Wars from Alexandria to Waterloo.

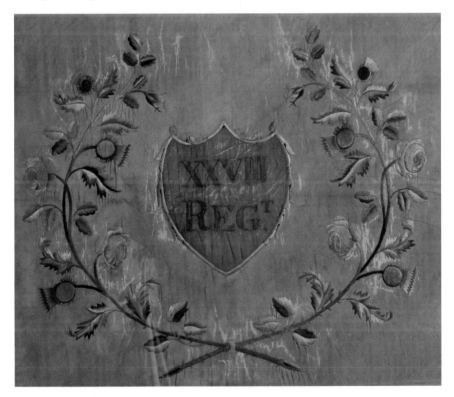

The Regimental Colour of the 28th (North Gloucestershire) Regiment of Foot. The image shows the details of the centre of the Colour, which was commissioned in 1795 and was almost certainly carried at the Battle of Alexandria. This particular Colour is very large, measuring 6ft by 6ft 6in and was made of silk. Although not shown in this image, the Union Flag in the corner of the Colour does not have the red St Patrick's Cross as this predates the Act of Union of Great Britain and Ireland.

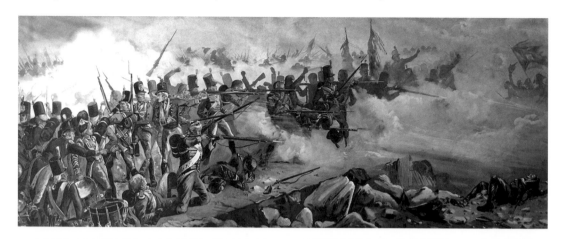

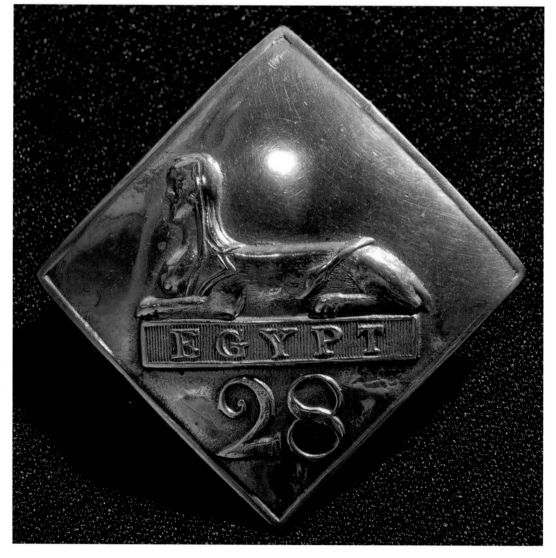

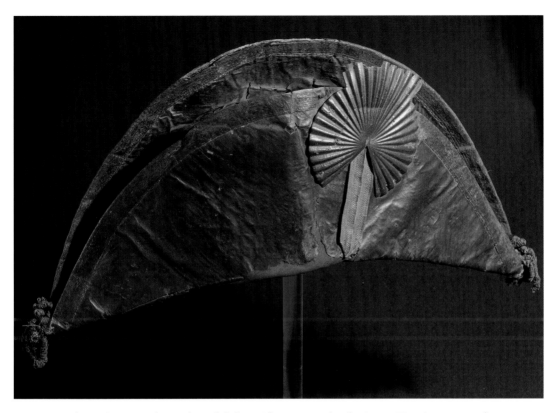

Above: As times changed, so did the uniforms worn by the Army. Here is an example of the bicorne cocked hat, as worn by senior officers during the Peninsular Campaign. This particular hat was worn by Major Thomas Wilson of the 28th Foot.

Opposite: One of the most important moments in our story was the Battle of Alexandria, which took place on 21 March 1801. The French had sent a force to Egypt as part of a plan to conquer India and the 28th formed part of the force sent to remove them. Before dawn on the 21st, the French commander, who had better artillery and 1,400 more cavalry, attacked the British, directing most of his forces against the British right, including the 28th, who were defending a ruined fort. Heavy fighting ensued, during which, while under very heavy attack from infantry troops to the front and flanks, French cavalry was thrown against the 28th rear. An order was given 'Rear Ranks 28th, right about face', and the regiment fought back-to-back against repeated French attacks. The attacks were all repelled in fierce hand-to-hand fighting, and the French were soon in full retreat. For their valour and bravery in this action, the 28th were granted the unique distinction of wearing a badge on the rear of their headdress as well as the front. This honour continues to this day, as do commemorations and services to mark Back Badge Day. Above is Colonel Marshman's painting of the 28th at Alexandria, and an example of the earliest known pattern of the Back Badge, as issued in 1805. The earliest versions were issued in silver, but its monetary value ensured it was a popular means among the rank and file of gaining some extra cash, so replacements were issued in silver plate. The design was simplified in 1830 and produced in brass.

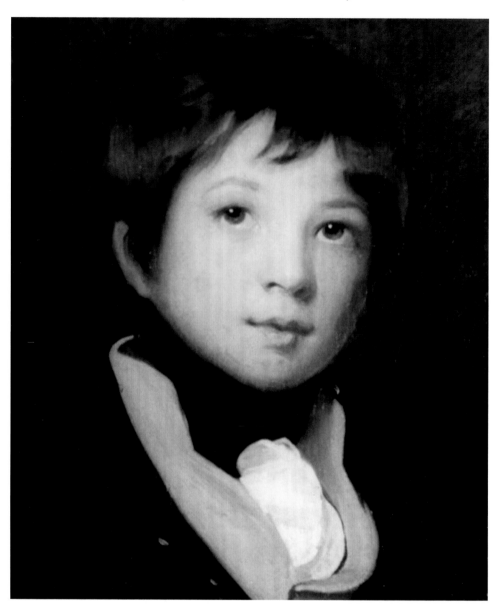

Samuel Edmund Falkiner joined the 61st (South Gloucestershire) Regiment of Foot at the age of just twelve (as can be seen in the portrait). His service coincided with the Peninsular Wars fought in Spain and Portugal against the French and Falkiner would be wounded at the Battle of Salamanca on 22 July 1812. During the battle, the 61st, along with 11th Foot, were tasked with capturing the Grand Arapile, a vital hill that had been lost to the French. This was achieved under heavy fire and numerous French attacks were repelled. As darkness fell, another cliff position was ordered to be attacked and the 61st suffered terrible casualties, with six separate Colour parties cut down. By the time of the final attack, there were no officers or sergeants remaining to carry the Colours, which were borne to the summit by two privates, Crawford and Coulson. The 61st went into battle with twenty-seven officers and 420 men, but of these, twenty-four officers and 342 men were killed or wounded. Falkiner survived and would live to the age of seventy-five.

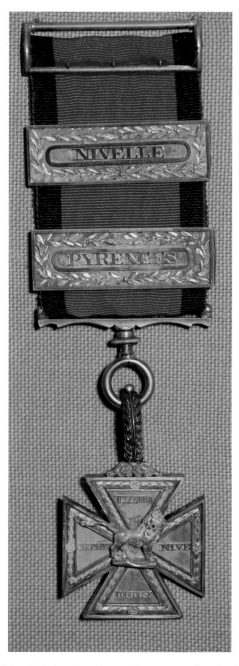

Lt-Col. James Coghlan led the 61st through numerous battles in 1813–14, before dying in action at Toulouse, where the regiment earned the nickname 'The Flowers of Toulouse' due to the number of red-coated dead they left on the battlefield. Coghlan was fatally wounded early in the battle and his funeral was attended by Wellington himself. The Army Gold Cross was awarded to senior officers who had been present at four or more battles, and Coghlan's was awarded posthumously for the Battles of Talavera, Nive, Orthes and Toulouse, with additional clasps for the Pyrenees and Nivelle.

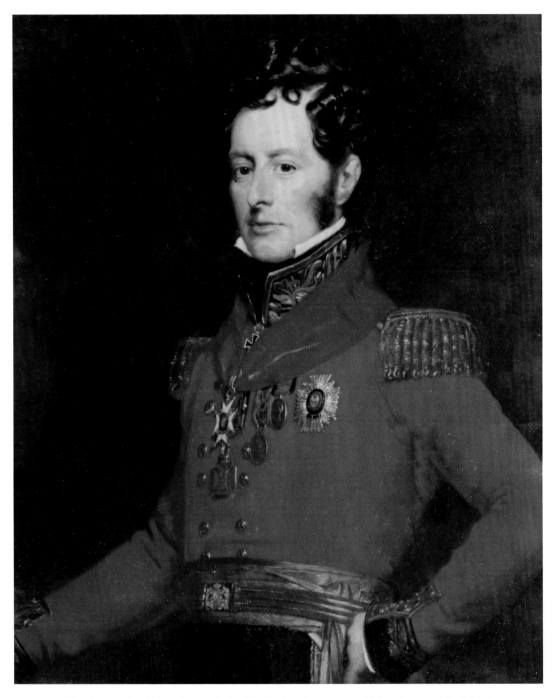

The Peninsular Campaign ended with the imprisonment of Napoleon on the island of Elba in 1814, but hostilities resumed the following year as Napoleon escaped and made a final bid for victory. The Duke of Wellington, commanding British and Allied forces, wanted as many of his battle-hardened Peninsular veterans as possible, and the 28th were urgently recalled to join Wellington in Belgium. The commander of the 28th at this time was Sir Philip Belson, pictured here.

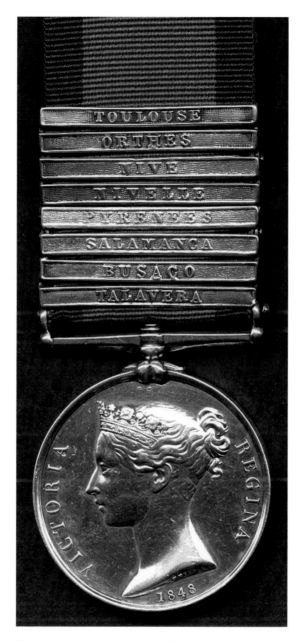

While senior officers received the Army Gold Medal and Army Gold Cross, junior officers and soldiers received no recognition at this time. Many years later, in 1847, the Military General Service Medal (MGSM) was approved as a retrospective award for various military actions between 1793 and 1814. Each battle or action was represented by a clasp. Interestingly, the medal was only awarded to surviving claimants; a recipient had to survive until 1847 and then actively apply for it. As a consequence, there are significantly fewer medals than men who served during this period. Here is an example of the MGSM, awarded in this case to Sergeant Richard Smyth of the 61st Foot with clasps for Talavera, Busaco, Salamanca, Pyrenees, Nivelle, Nive, Orthes and Toulouse.

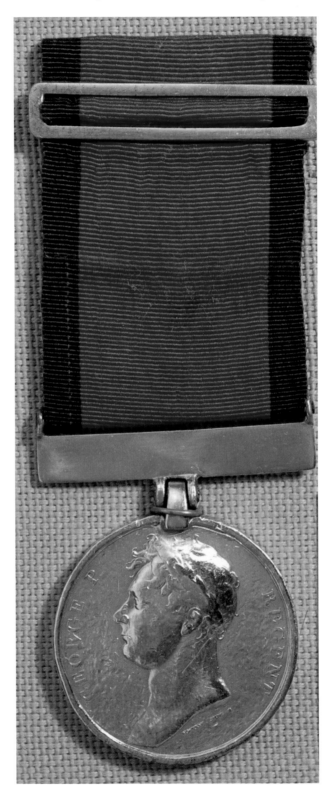

Right and opposite: Following the defeat of Napoleon at Waterloo the British Government issued the Waterloo Medal, the first medal ever issued to all soldiers present at an action. This proved unpopular with veterans of the Peninsular War, who would have to wait until 1847 for their service to be recognised. The medal is unusual in that it depicts the head of the Prince Regent on the obverse, whereas all other medals depict the reigning monarch. The example shown here was awarded to Capt. Arthur Shakespear. Shakespear served in the 10th Royal Hussars, and in 1834 was invited to take the rank of major in the newly formed regiment of Gloucestershire Yeomanry Cavalry, the forerunner of the Royal Gloucestershire Hussars.

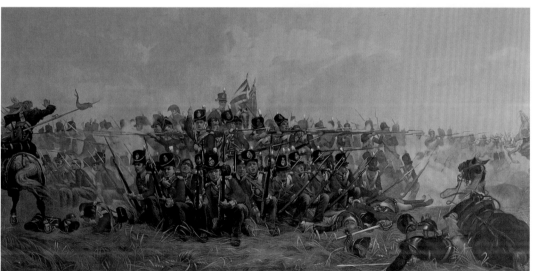

Following his escape from Elba, Napoleon's tactic was to split his forces in two and simultaneously attack Wellington's forces at Quatre Bras and the Prussian army, under the command of Blucher, at Ligny. On 16 June 1815, the 28th stood firm in a field of tall rye despite continuous attacks from the French who had all but broken the British regiments on their right flank. This stand at Quatre Bras, immortalised in Lady Butler's famous painting, prevented a French victory. However, Napoleon had forced the Prussians from the field at Ligny, so the 28th had to retreat towards Brussels to prepare for a final onslaught from the French at Waterloo.

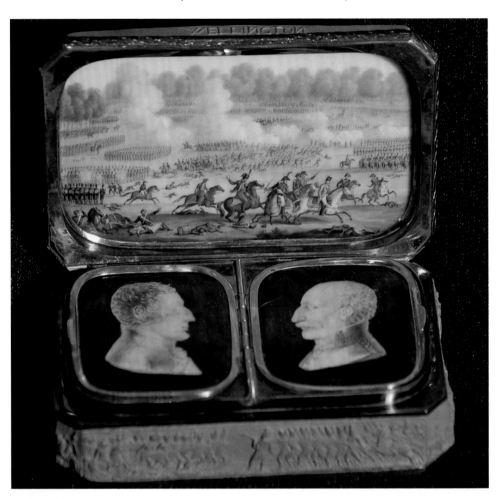

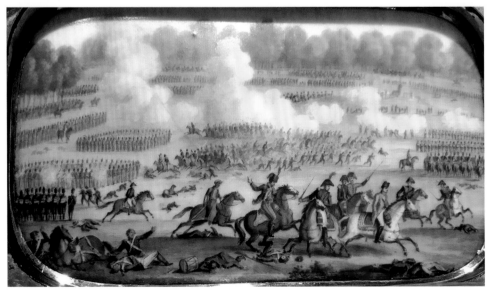

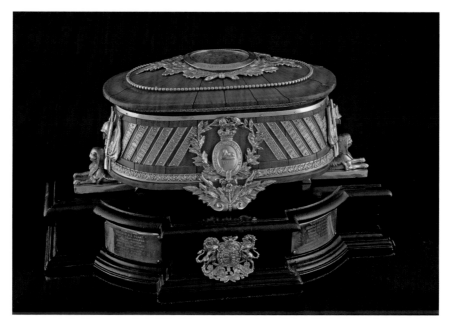

Above, below and opposite: After their stand at Quatre Bras, the 28th joined the main Allied army at Waterloo. Wellington's plan was to hold firm until Blucher's Prussian army had recovered sufficiently to join him and achieve victory. On 18 June 1815, Napoleon launched attack after attack against the Allied forces. The 28th, placed in the centre, were subject to numerous attacks but held firm. As evening approached, Napoleon received word the Prussians were arriving and, in an act of desperation, flung the famed Imperial Guard into action, but they too were repulsed. The 28th fought with such bravery that they would be singled out for particular praise by Wellington in his famous despatch. As Wellington himself said, 'It was a damned serious business ... the nearest thing you ever saw in your life.' The museum is home to a number of items relating to Quatre Bras and Waterloo, including a snuffbox carried by Sir Philip Belson and presented to the officers of the 28th following his promotion to commemorate the part played by the regiment in the battles. The basalt of the box is carved with scenes of the 28th's exploits during the Napoleonic Wars, with the underside of the lid containing a porcelain panel depicting the Battle of Waterloo and the lids of the two snuff compartments showing cameos of Wellington and Blucher. In addition is the spectacular Waterloo Casket, carved from the wood of the staves that carried the regimental Colours. The Battle Honours of the regiment are engraved in gold around the casket, and the glass panel on the lid contains the surviving pieces of the Colours of the 28th carried at Waterloo.

28th, or North Gloucestershire Regiment.

LIST of Officers, Non-commissioned Officers, Drummers and Privates, Killed, Wounded &c. at the BATTLE OF WATERLOO, on the 16th, 17th and 18th June, 1815.

RANK.	NAMES.	REMARKS.	RANK.	NAMES.	REMARKS.	RANK.	NAMES.	REMARKS.
Major Bt Lt.Col.	R. Nixon	Wounded 18th	Private	E. Chapman	Wounded 18th	Private	H. M'Cormick	Wounded 18th
Capt. & Bt. Major	W. P. Meacham	Killed 18th	,,	J. Cruise	do. 16th, s.D.	,,	P. M'Cann	do. 16th
,,	W. Irving	Wounded 16th	,,	B. Connolly	do. 18th	,,	M. Minnick	do. 16th
,,	R. Llewellyn	do. 18th	,,	J. Cole	do. 16th	,,	C. M'Cann	do. 18th
Captain	J. Bowles	do. 16th	,,	J. Conway	do. 18th	,,	J. Mount	do. 16th
,,	T. English	do. 18th	,,	E. Davey	do. 16th	,,	J. Marshall	do. 18th
,,	R. Kelly	do. 18th	,,	P. Donnolly	do. 18th	,,	G. Marshall	do. 18th
Lieutenant	I. Cocu	Wounded 16th	,,	T. Durr	do. 16th	,,	W. Miners	do. 18th
,,	C. B. Carrothers	do. 18th	,,	H. Daniels	do. 18th	,,	T. M'Parlane	do. 18th
,,	I. T. Clarke	do. 18th, s.D.	,,	J. Davers	do. 18th	,,	H. Murry	do. 16th
,,	J. W. Deares	do. 18th	,,	M. Davis	do. 18th	,,	J. Murphy	do. 16th
,,	R. P. Eason	do. 18th	,,	A. Dooling	do. 16th	,,	J. M'Guinness	do. 16th
,,	R. P. Gilbert	do. 18th	,,	G. Davis	do. 16th, s.D.	,,	R. M'Guinn	do. 18th
,,	H. Hilliard	do. 18th	,,	J. Drennon	do. 16th	,,	J. Murphy	do. 18th
,,	G. Ingram	Killed 16th	,,	I. Dawe	do. 16th	,,	D. M'Gaw	do. 18th
,,	W. Irwin	Wounded 16th	,,	W. Elliott	do. 18th	,,	A. M'Donald	do. 18th
,,	J. W. Shelton	do. 18th	,,	J. Evory	do. 18th	,,	P. M'Curry	do. 18th
,,	J. F. Wilkinson	do. 18th	,,	J. Finnagan	Killed 16th	,,	B. M'Anulty	do. 18th
Lieut. & Adjutant	T. Bridgeland	do. 18th	,,	J. Francis	P. War 17th	,,	M. M'Fadden	do. 18th
Ensign	W. Mounsteven	do. 18th	,,	J. Fennell	Wounded 18th	,,	R. Montgomery	do. 18th
Serjeant Major	R. Irwin	do. 18th	,,	T. Fisher	do. 18th	,,	M. Naughton	Killed 18th
Serjeant	P. Lynch	do. 18th	,,	P. Fogerty	do. 18th	,,	M. Neiry	Wounded 16th
,,	R. Charlesworth	do. 18th	,,	J. Fielding	do. 18th	,,	I. Nary	do. 16th
,,	S. Cockrane	Killed 18th	,,	J. Fisher	do. 18th	,,	J. Needham	do. 16th
,,	T. Davies	Wounded 16th	,,	R. Fullerton	do. 18th	,,	J. Neill	do. 18th
,,	G. Dawley	do. 18th	,,	P. Fox	do. 16th	,,	R. Nicholson	do. 18th
,,	W. Goodfellow	do. 16th	,,	D. Green	do. 18th, s.D.	,,	W. Newcombe	do. 18th
,,	W. Kerr	do. 18th	,,	W. Gaynon	do. 16th	,,	T. O'Brien	do. 18th
,,	P. Matthews	do. 18th	,,	C. Grant	do. 16th	,,	I. O'Brien	do. 18th
,,	M. O'Conner	do. 18th	,,	J. Gibbs	do. 18th	,,	J. O'Neill	do. 18th
,,	W. Plugnott	do. 18th	,,	M. Gordon	do. 18th	,,	S. Penny	Killed 18th
,,	J. Rutherford	do. 16th	,,	B. Gahan	do. 18th	,,	W. Pratt	Wounded 16th
,,	E. Ryan	do. 18th	,,	J. Galvin	do. 16th	,,	W. Peznum	do. 18th
,,	J. Taylor	do. 18th	,,	R. Gerrett	do. 18th, s.D.	,,	J. Pugsley	do. 16th
Corporal	M. Brennon	do. 18th	,,	J. Glynn	do. 18th	,,	R. Penny	do. 16th
,,	W. Bresland	do. 16th	,,	P. Goggerty	do. 18th	,,	R. Palmer	do. 16th
,,	I. Finnagan	do. 16th	,,	J. Gannon	Killed 18th	,,	C. Pepperal	do. 18th
,,	T. Grenham	Killed 18th	,,	C. Hobb	Wounded 18th	,,	W. Pearce	do. 18th
,,	J. Graham	Wounded 16th	,,	G. Hawkins	do. 16th	,,	A. Perfect	do. 16th
,,	T. Hammer	do. 18th	,,	M. Hogan	do. 16th, s.D.	,,	C. Palmer	do. 18th
,,	R. Johnson	Killed 16th	,,	P. Hickey	do. 18th	,,	P. Quinn	do. 18th
,,	I. King	Wounded 18th	,,	J. Harding	do. 16th	,,	I. Quinn	do. 18th
,,	I. Morris	do. 17th	,,	M. Hunt	do. 18th	,,	G. Robins	do. 16th
,,	H. Ralston	do. 18th	,,	B. Hiscox	do. 16th	,,	I. Reay	do. 16th
,,	J. Roberts	do. 16th	,,	D. Higgs	do. 16th	,,	H. Rowe	do. 18th
,,	B. Sweeney	do. 16th	,,	J. Hanraghan	do. 18th	,,	I. Ryan	do. 18th
,,	I. Streets	do. 16th	,,	P. Hughes	do. 18th	,,	H. Robins	do. 16th
,,	M. Talbott	do. 18th	,,	J. Humphries	do. 18th	,,	M. Rafferty	do. 16th
,,	W. Wheeler	do. 18th	,,	P. Hanover	do. 18th	,,	G. Robins	do. 18th
Drummer	I. Hill	do. 18th	,,	W. Hearne	do. 18th	,,	W. Shipcott	Killed 18th
Private	J. Adams	do. 18th	,,	P. Hughes	do. 18th	,,	G. Smith	do. 18th
,,	T. Ash	do. 18th	,,	A. Henderson	do. 16th	,,	E. Summers	do. 16th
,,	H. Abercromby	do. 18th	,,	I. Handsberry	do. 16th	,,	R. Scrivens	do. 16th
,,	J. Amos	do. 18th	,,	M. Huxter	do. 16th	,,	I. Shawe	do. 18th
,,	W. Axford	P. War 17th	,,	E. Hardiman	do. 18th	,,	M. Smith	Wounded 16th
,,	D. Allums	Wounded 16th	,,	A. Hamond	do. 18th	,,	I. Sheppard	do. 16th, s.D.
,,	W. Brien	do. 16th	,,	I. Johnston	do. 18th	,,	W. Sheedy	do. 16th
,,	J. Burnett	do. 18th	,,	I. Jewson	do. 18th	,,	I. Smally	do. 18th
,,	M. Barnes	do. 18th	,,	T. Jeanes	do. 16th	,,	W. Sarah	do. 16th
,,	E. Brittain	do. 18th	,,	M. Jackson	do. 16th	,,	I. Slugg	do. 16th
,,	J. Bartley	do. 16th	,,	W. Jennings	Killed 18th	,,	W. Soabey	do. 16th
,,	I. Bond	do. 18th	,,	T. Kinsman	Wounded 18th	,,	P. Smith	do. 18th
,,	J. Beckwith	Killed 18th	,,	T. Kendle	do. 16th	,,	I. Stanning	do. 18th
,,	W. Blackmore	do. 17th	,,	W. Jefferics	do. 18th	,,	I. Stuckey	do. 16th
,,	J. Brooks	do. 16th	,,	J. Kearnes	do. 12th	,,	W. Sandford	do. 18th
,,	R. Black	Wounded 18th	,,	W. Ketterick	do. 16th, s.D.	,,	I. Tank	do. 16th
,,	J. Browning	do. 18th, s.D.	,,	J. Keenan	do. 18th	,,	T. Toogood	do. 16th, s.D
,,	A. Cole	Killed 16th	,,	J. Leonard	Killed 18th	,,	W. Taylor	do. 18th
,,	J. Conlon	do. 18th	,,	J. Loads	do. 18th	,,	I. Underwood	do. 18th
,,	P. Conolly	do. 18th	,,	R. Luxham	do. 18th	,,	W. Vickers	do. 18th
,,	T. Clarke	do. 16th	,,	R. Lendles	Wounded 18th	,,	S. Withiel	P. War 17th
,,	J. Callaghan	do. 18th	,,	T. Ludden	do. 16th	,,	G. Woods	Wounded 16th
,,	A. Crozier	do. 18th	,,	J. Lemman	do. 18th	,,	J. Watts	do. 18th
,,	J. Crawley	Wounded 18th	,,	J. Lennon	do. 18th	,,	A. Webb	do. 18th
,,	W. Chubb	do. 18th	,,	G. Laviss	do. 18th	,,	M. Watson	do. 18th
,,	W. Cavanagh	do. 18th	,,	D. M'Shane	Killed 18th	,,	H. White	do. 18th
,,	J. Connors	do. 18th	,,	R. M'Awley	do. 16th	,,	I. Woodward	do. 18th
,,	T. Condon	do. 16th	,,	F. M'Guire	do. 16th	,,	W. Waters	do. 18th
,,	J. Connell	do. 18th	,,	J. Major	do. 18th	,,	T. Williams	do. 18th
,,	C. Connolly	do. 16th	,,	E. Moore	do. 18th	,,	I. Worley	do. 18th
,,	M. Cottle	do. 18th	,,	J. Madden	do. 18th	,,	A. Withered	do. 16th
,,	B. Clarke	do. 17th	,,	G. Montgomery	Wounded 16th	,,	J. Wilson	do. 18th
,,	I. Campbell	do. 18th	,,	M. Martin	do. 16th, s.D.	,,	S. Williams	do. 18th
,,	S. Cross	do. 18th						

RECAPITULATION.

	Lt. Col.	Majors.	Captains.	Lieuts.	Ensigns.	Staff.	Serjts.	Corporals.	Drummers.	Privates.	Total.
Killed	0	1	0	2	0	0	1	2	0	38	44
Wounded	1	2	3	9	1	1	13	13	1	159	203
Missing	0	0	0	0	0	0	0	0	0	3	3
Total	1	3	3	11	1	1	14	15	1	200	250

JAMES BURRILL, Army Printer, High-street, Chatham.

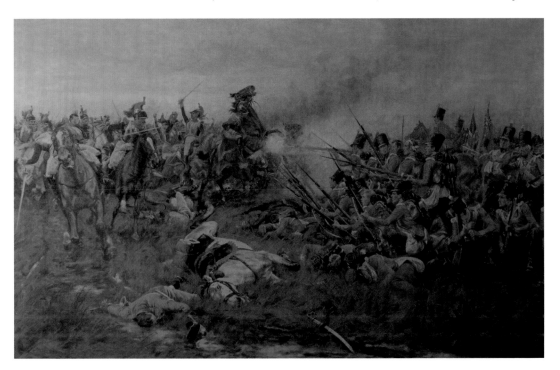

Above: During these three days in June 1815, the 28th fought with discipline and valour, standing firm despite continuous attacks from the French. At Quatre Bras one of the officers wrote, 'The rye in the field was so high, that to see anything beyond our ranks was almost impossible. The Enemy, even, in our Squares, were obliged to make a daring person desperately ride forward and plant a flag, as a mark, at the very point of our bayonets. On this they charged, but were invariably repulsed.' Two days later at Waterloo they were attacked by D'Erlon's French 1st Corps. Some of the Allied forces alongside the 28th retreated when they saw the size of the French attack, but the 28th, alongside the 32nd and 79th Foot, met them at the charge, where they 'completely repulsed the Enemy's Column, driving it in a state of the greatest confusion down the slope of the position'. The accompanying painting shows the severity of the fighting, which would end with a French defeat.

Opposite: The battles at Quatre Bras and Waterloo would lead to a long period of peace in Europe following Napoleon's defeat and exile. However, this came at considerable cost to the men of the 28th, as can be seen in the casualty figures published following the battles. While there would be relative peace in Europe, the men of the 28th and 61st would spend most of the next century engaged around the world.

Above, below and opposite: As has been seen previously, uniforms and headdresses changed regularly and shown here is a good example of an officer's Regency pattern shako, as worn between 1816 and 1822. Also shown is an example of the headdress worn by men of the 61st in the middle of the nineteenth century and a canvas backpack carried through the Crimea campaign by a soldier of the 28th.

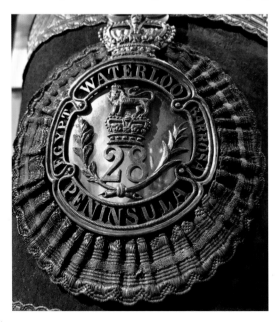

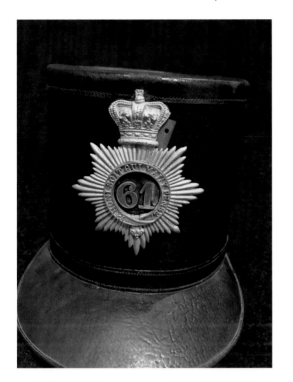

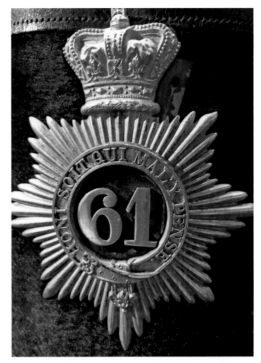

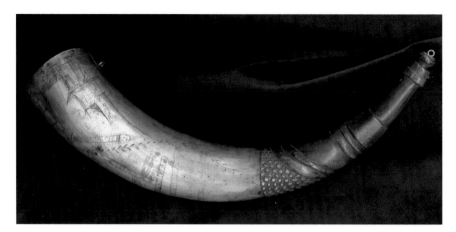

Above and below: From 1835 to 1842, the 28th were stationed in Australia, guarding the penal colonies. A large number of men would eventually settle in Australia and played a significant role in the expansion of Sydney and New South Wales, the development of Melbourne and the wider development in the decades that followed. Shown here is a powder horn owned by Private Charles Willis, who served with the 28th on convict duty from 1836 to 1839. The horn dates to 1838 and its detailed scrimshaw design includes 28th Foot Regimental badges, battle honours from the Napoleonic Wars, naval vessels, Australian flora and fauna, notably an emu and a kangaroo, and more. Willis himself injured his thumb when his musket accidentally slipped from his shoulder while on convict guard duty and he was discharged on sixpence a day.

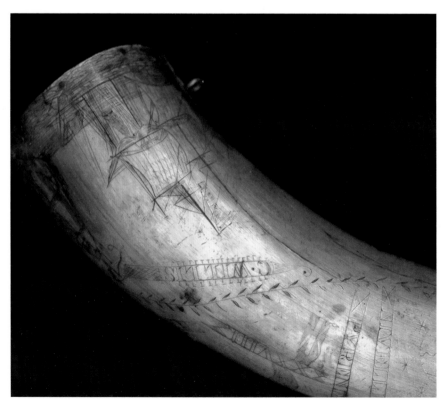

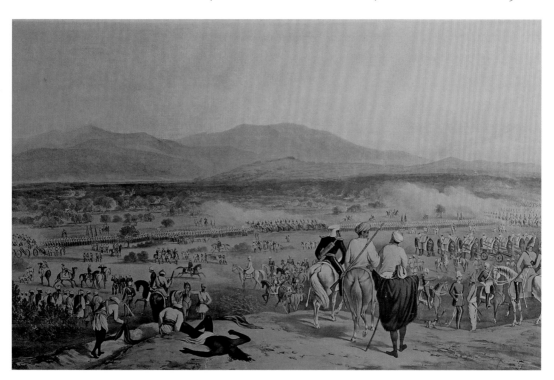

Above and overleaf: In 1848, the 61st sailed for Calcutta and joined General Gough's forces in the Second Anglo-Sikh War that followed. The Sikh army numbered 32,000 and outnumbered the British three to one. However, it was beaten and broken on 13 January 1849 at the Battle of Chillianwallah. Chillianwallah was known as the Waterloo of India, as the result was in serious doubt for some time and the consequences of the British victory were significant. The British had to advance through dense jungle and, as a result, lost touch with each other, leading to some confusion. The 61st, on the left of the British line, stormed the Sikh batteries in front of them and then turned right and advanced almost single-handed along the main position of the enemy, although at one point, in an attack reminiscent of the 28th at Alexandria, they were attacked from the rear by cavalry and fought them off. Shown here is a shell jacket, bloodstained and repaired, worn by Major Charles Clement Deacon at the Battle of Chillianwallah, which can be seen in the lithographic print.

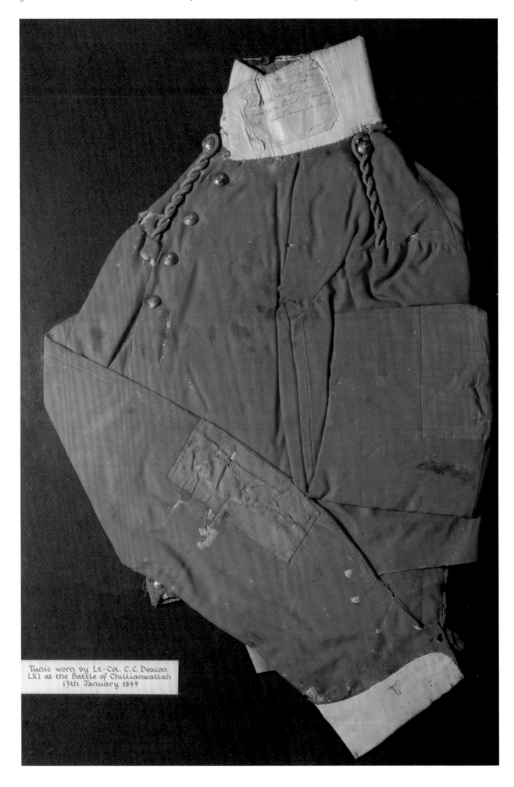

Tunic worn by Lt-Col. C.C. Deacon LXI at the Battle of Chillianwallah 13th January 1849

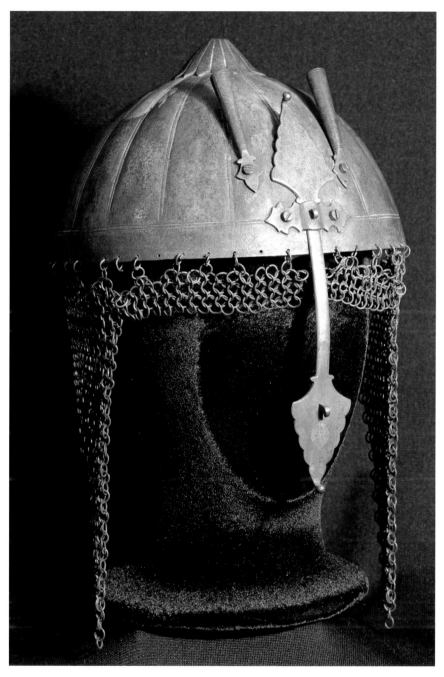

Following Chillianwallah, and the Battle of Goojerat which immediately followed it, the British gained control of the Punjab and the 61st would spend the next eight years based in Peshawar on garrison duties. This Mughal helmet was taken during this time by Lt Thomas Gordon. Interestingly, the 61st set a new fashion trend during their time in Peshawar by becoming the first regiment to dye their tropical uniforms 'a sort of bluish-brown colour, known out here as karky'. This would be the beginning of the end of the famous Redcoats.

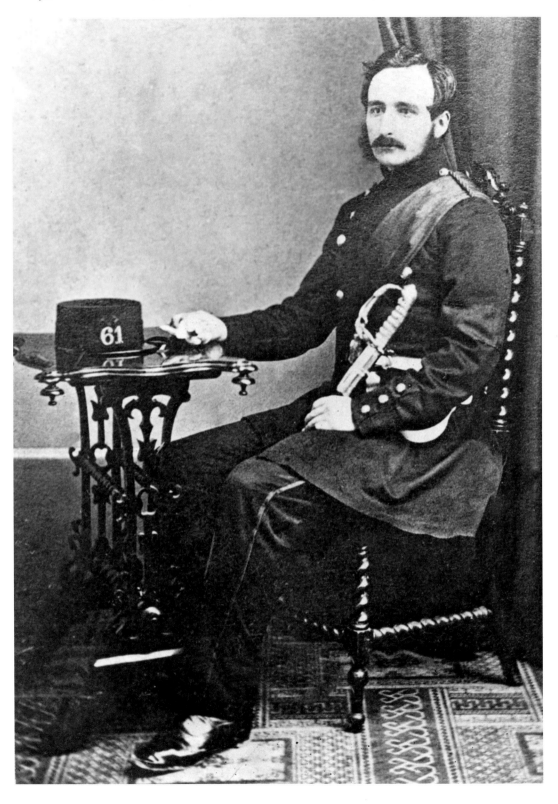

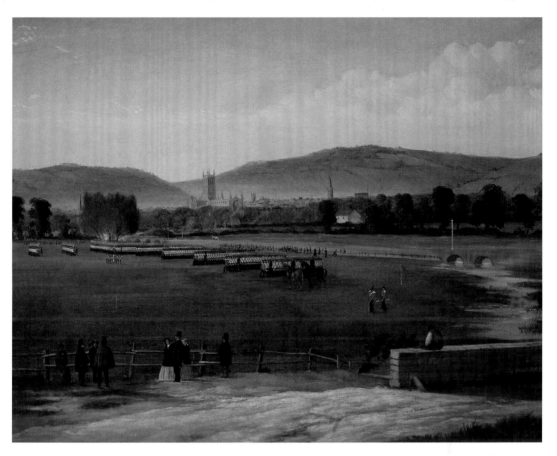

Above: While the 61st were in India, and the 28th were moving towards the Crimea, local militia were still recruiting and serving within the county. This painting of the Royal South Gloucestershire Militia being reviewed on the Ham in 1854 shows the regiment in the shadow of Gloucester Cathedral.

Opposite: The mid-nineteenth century also saw the rapid expansion of photography and as the technology developed it became more common for photographs to begin to replace paintings and drawings within the regiments. One of the earliest surviving photographs in our collection, taken in 1852, shows Major John Sloman, an officer of the 61st.

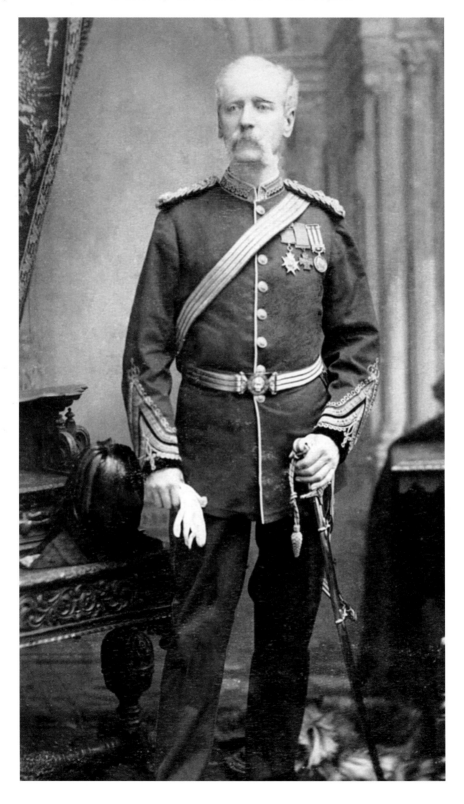

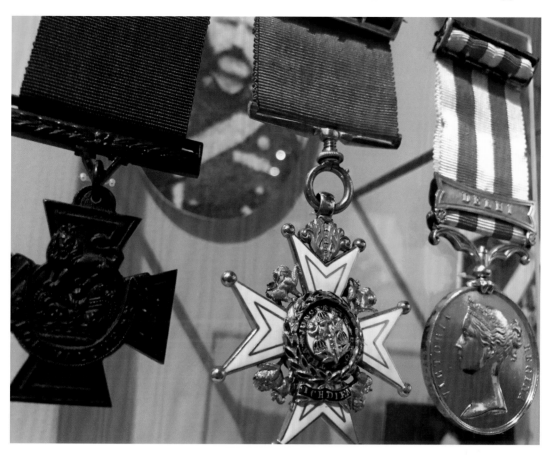

Above and opposite: The 61st had remained in India since the Second Sikh War and in 1857 were stationed in Ferozepore when the Indian Mutiny erupted. The Officers' Mess was burned to the ground, resulting in the loss of the Regimental Silver, before the focus turned to Delhi. One member of the regiment was the Regimental Surgeon, Herbert Taylor Reade, who can be seen in later years here. In September 1857, Reade organised and led a small group of volunteers to dislodge some mutineers who were firing on the wounded soldiers he was treating. Eight out of his party of ten were killed or wounded, but the mutineers were forced to retreat. Two days later, Reade was one of the first into the breach in the assault on the Magazine in Delhi and successfully spiked one of the mutineers' guns. As a result of his extraordinary bravery, Reade became the first man in the regiment to be awarded the nation's highest award for valour, the Victoria Cross, which is on permanent display in the museum.

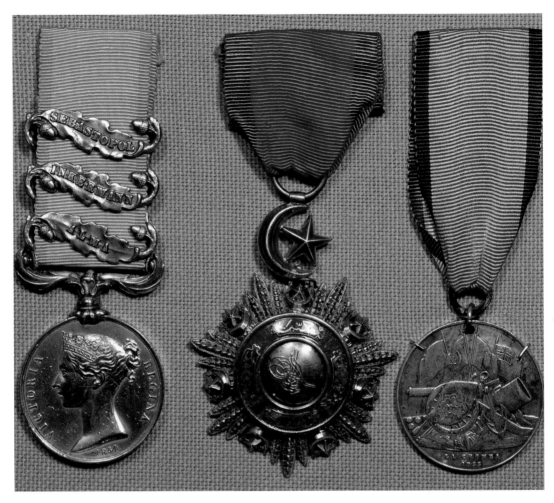

In 1854, the 28th were despatched to Russia on the outbreak of the Crimean War. For the first time in centuries, French and British soldiers were allies and fighting alongside each other. However, as was common throughout the eighteenth and nineteenth centuries, it was sickness that was a worse adversary than the enemy. The 28th were ravaged with cholera and suffered numerous casualties to the disease. Nevertheless, they fought strongly at Alma, Inkerman and the Siege of Sevastapol, and pictured here is an example of the campaign medals awarded during this war. It contains the Crimea Medal with clasps for the three actions in which the 28th fought, the Turkish Crimea Medal and the Turkish Order of Medjidie, awarded to Capt. Godley. The Battle of Alma was also the final occasion on which the Colours of the Regiment were carried into battle, as developments in tactics and weapon technology changed the nature of how battles would be conducted in the future.

Above and overleaf: Reade was not the only member of the 61st who performed extraordinary feats during the Indian Mutiny. The Colours of a regiment were incredibly important symbols and would be defended at all costs. The loss of the Colours was a very rare event, and one that would be a source of great pride for the captors as the capture of an enemy's standard was considered a great feat of arms. The 61st felt such pride when the Colours of the 41st Bengal Native Infantry Regiment were taken by the Regimental Sergeant Major of the 61st, H. G. Baker, pictured here. Baker was awarded the Distinguished Conduct Medal for his actions in 1857. The gold half-hunter watch (donated to the museum by the Baker family) was made for Baker by a renowned watchmaker in the Strand and carried throughout his career, and the accompanying brooch was presented to Baker by Shah Bahadur, King of Delhi, following the capture of the city. Bahadur Shah Zafar was the last Mughal Emperor of India and a renowned poet. Following the capture of Delhi, he was placed under arrest and was guarded by the 61st. Baker eventually became a Yeoman Warder at the Tower of London.

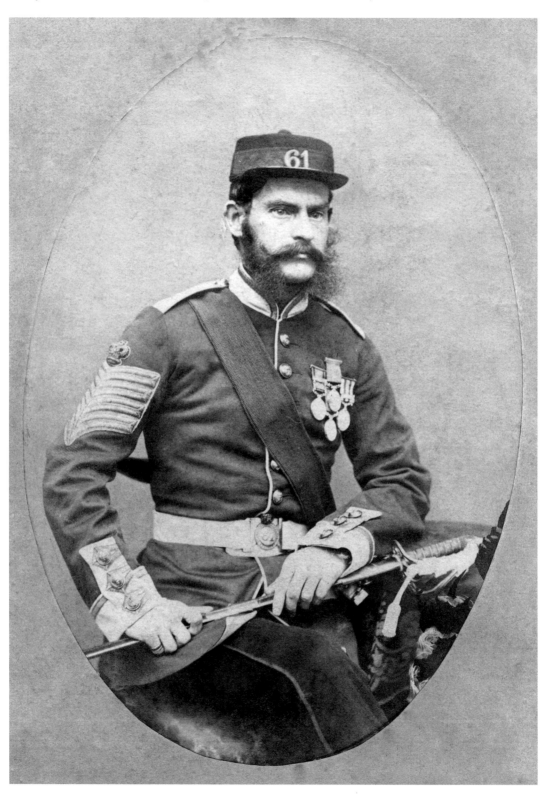

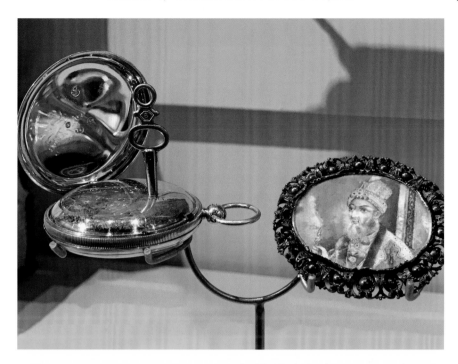

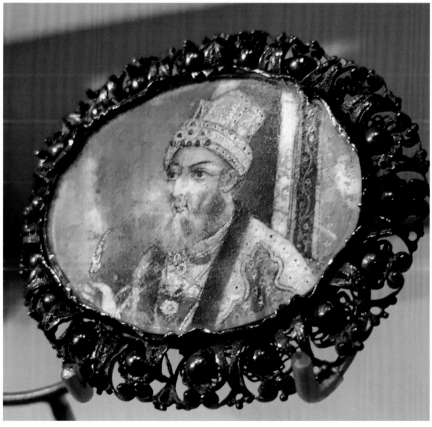

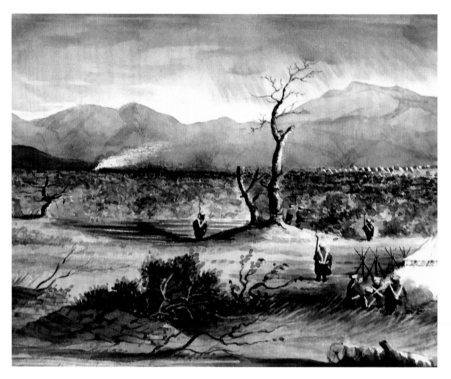

Above and below: Regiments would often have talented artists in their midst and the museum has numerous examples of pieces of art produced by soldiers in the field. One of these was Capt. W. E. D. Deacon, who was stationed in India and carried a sketchbook with him throughout his service. His roadside sketches present a fascinating view of life in India.

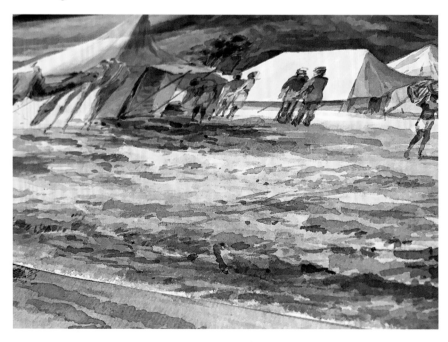

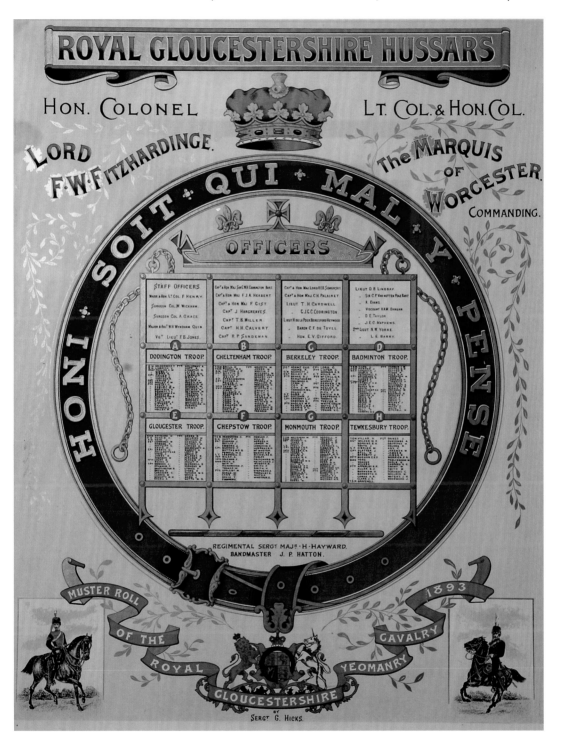

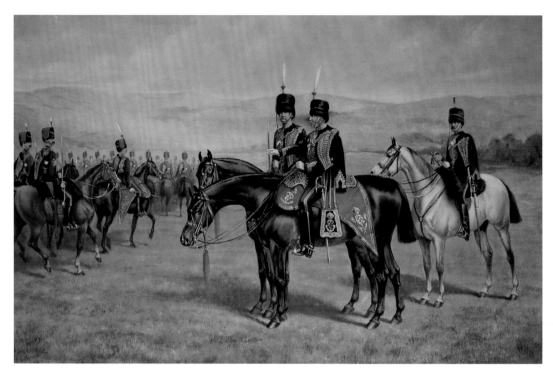

Previous and above: On 30 March 1834, a meeting took place in Petty France, near Badminton, where the assembled captains of Gloucestershire troops agreed to combine to form a single regiment to be called the Gloucestershire Yeomanry Cavalry. The title of 'Royal' was granted in 1841 and the regiment was renamed the Royal Gloucestershire Hussars in 1846. Throughout the remainder of the nineteenth century, the regiment continued to train within the county and they recruited strongly from established county families such as the Cliffords of Frampton, the Bathursts of Cirencester, the Yorkes from Forthampton and many others. The first Commanding Officer was the Marquis of Worcester, future 7th Duke of Beaufort, establishing a connection with the Somerset family that continues to this day. The illuminated muster roll shows the composition of the Royal Gloucestershire Hussars (RGH) in 1893, while the oil painting, entitled 'The Blue Duke', shows a review of the RGH at Prestbury Park, Cheltenham by the 8th Duke of Beaufort, accompanied by the Commanding Officer, his son, the Marquis of Worcester in 1894.

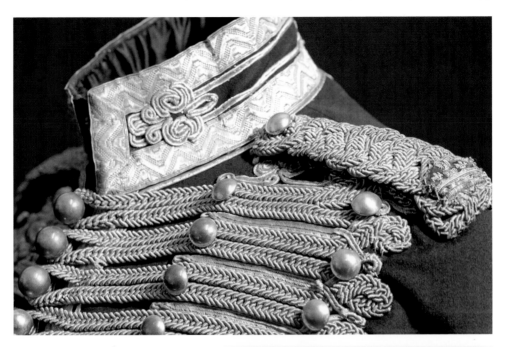

Above and right: The RGH had begun wearing the distinctive blue Hussar uniform in 1847. The collar detail of this uniform can be seen here.

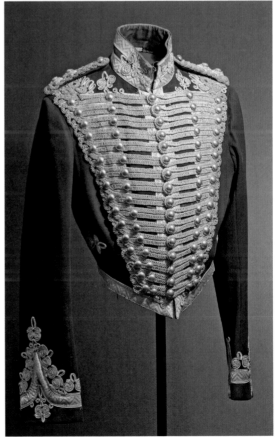

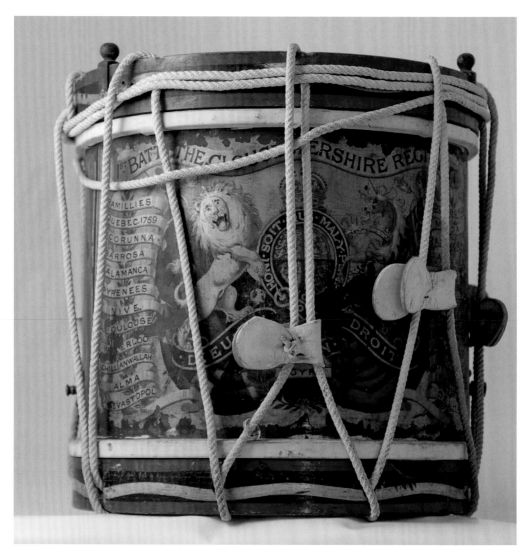

In 1881, there was a major change to the structure of the army when the numbering system of the Regiments of Foot was replaced with the introduction of new county regiments and the old 28th and 61st were linked together to form the 1st and 2nd Battalions of the Gloucestershire Regiment. At the same time, the other units of militia and volunteers within the county, forerunners of the Territorial regiments, were also reorganised and brought into the family circle of the Gloucestershire Regiment as the 3rd and 4th Battalions. While the names may have changed, the spirit and traditions remained undimmed and the pride in the accumulated histories of their forefathers was retained in the battle honours that adorned items such as the side drum of the 1st Battalion from 1900.

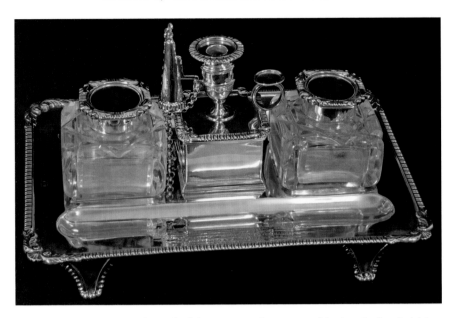

War broke out again at the end of the nineteenth century, this time in South Africa, and both the 1st and 2nd Battalions of the Gloucestershire Regiment, as well as men from the Volunteer Battalions and 123 troops from the Royal Gloucestershire Hussars would see action. Prior to departure, the RGH had been stationed at Horfield Barracks, Bristol, home of the Gloucestershire Regiment, and pictured is a silver desk set presented by RGH officers following their mobilisation in February 1900.

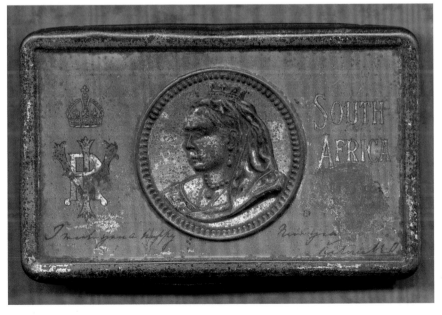

As the war continued, the Queen decided to send a special gift to survivors from the Siege of Ladysmith. Pictured is one of twelve small chocolate gift boxes, bearing the face of Queen Victoria, despatched in time for New Year 1900, that were awarded by ballot to members of the regiment who had survived.

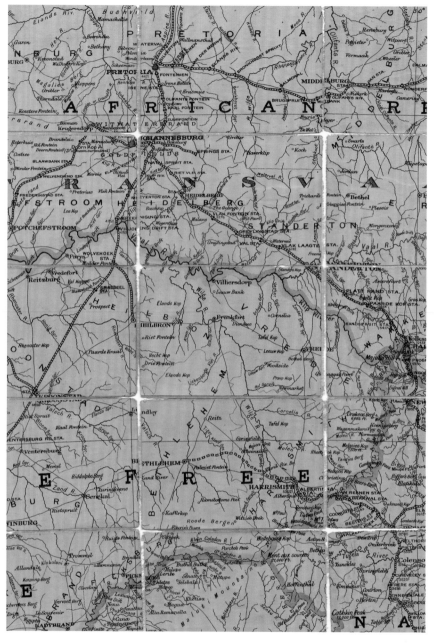

The 1st Battalion landed in South Africa on 13 October 1899, just two days after the war had begun. Within a fortnight they had seen action, the first since the Crimea nearly half a century earlier, and the Commanding Officer, Lt-Col. Welford, was killed in action. Four days later, a small column was sent to occupy a hill feature named Nicholson's Nek. One of those men was Lt A. H. Radice, whose linen map of parts of the Transvaal and Orange Free State is shown here. Radice was captured at the battle and the map found its way into the possession of a Boer soldier. Sometime later, the Boer was killed by Private Thomas Lodge of the Dorsetshire Regiment, who would eventually return the map to the regiment.

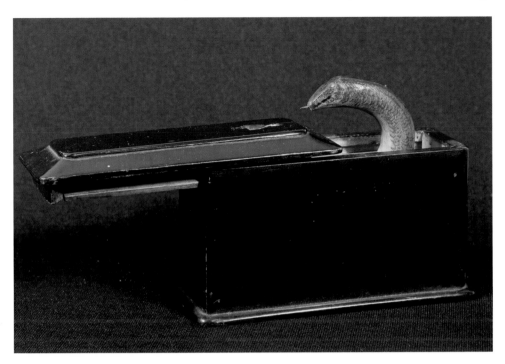

Above and below: Other, more unusual, items have survived from the Boer War to find their way into the museum collection. Cyril Herbert-Smith served with the 4th (Militia) Battalion during the war and brought back a toy made by a Boer prisoner of war. The wooden snake, waiting to strike from the box, contains a spike in its mouth, which would have caused a nasty injury to anyone playing with it.

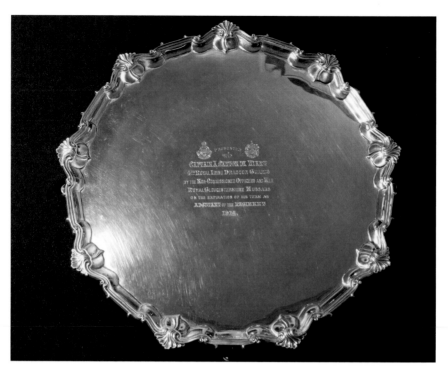

Above and below: Regiments throughout the British Army have a fondness for pieces of silver commissioned to mark special occasions, and the museum houses many such pieces. Capt. Adrian Carton de Wiart served as Adjutant of the RGH between 1912 and 1914. On the expiration of his term, the NCO's and men of the RGH presented de Wiart with a silver salver. In the First World War, de Wiart would emerge as one of the most remarkable soldiers in the country and would be awarded the Victoria Cross in July 1916 for extraordinary feats of courage while commanding the 8th Gloucesters at the Battle of the Somme. de Wiart is an extraordinary man whose story is impossible to tell in such a small space but is worthy of further investigation.

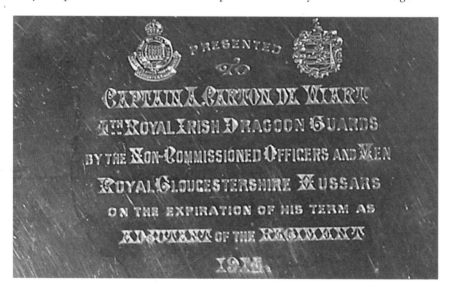

6TH BATT. GLOUCESTER REGT.

HEAD QUARTERS:
ST. MICHAEL'S HILL, BRISTOL.

— THE —

GALLANT SIXTH

Follow the Gloster Boys and Fill the Gaps in the Fighting Line of

THE SIXTH AT THE FRONT

Every Man must do his bit, or he will be ashamed to meet the Gloster Boys when they return.

Following the Boer War, the War Minister Lord Haldane identified a number of weaknesses in the army and introduced a series of reforms aimed at developing a fighting force that was able to adapt quickly and efficiently to changing demands should a European war occur, which was looking increasingly likely. One of those changes was the reorganisation of the militia and volunteers and the introduction of Territorial battalions. As a result, the 4th, 5th and 6th Battalions were raised, with the 4th and 6th recruiting from Bristol and the 5th from the county. When war broke out on 4 August 1914, recruiting notices were posted targeting men in Bristol to join the 6th.

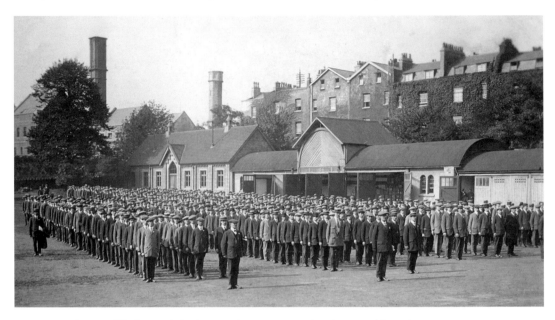

Above and below: While the initial recruiting to the Territorial battalions was a great success, it was quickly realised that an entirely new force would be needed in what was proving to be a titanic struggle. Kitchener's Army, as it would come to be known, was raised from the floods of volunteers who rushed to sign up and new battalions were raised in Gloucester, Cheltenham, the Forest of Dean and Bristol. One of these, the 12th (known as Bristol's Own), paraded their new recruits on Whiteladies Road in Bristol, seen here. Altogether twenty-four battalions of the Gloucestershire Regiment were in existence during the war and sixteen saw active service on the front line.

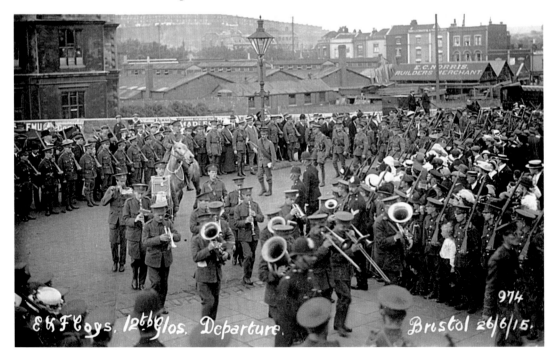

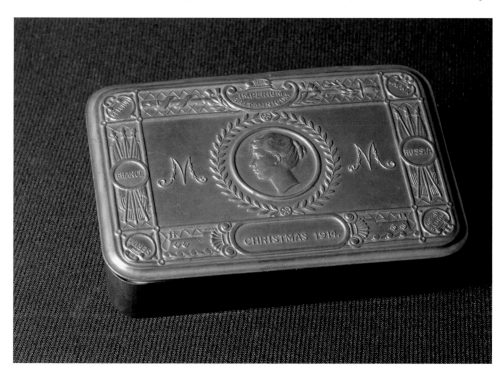

Above and below: The 1st Battalion were part of the British Expeditionary Force and were in France within a week of war being declared. The 2nd Battalion had been stationed in Tientsin, China, but moved with all haste and were in France before Christmas 1914. The first Christmas of the war came after very heavy fighting, significant casualties and a growing awareness that this was not going to be a quick affair. Following the lead of Queen Victoria fourteen years earlier, Princess Mary commissioned and distributed a gift box to the troops, pictured here. It is impossible in this publication to tell the story of the First World War, but the items that follow should provide a small glimpse into the horrors that would last for the next four years.

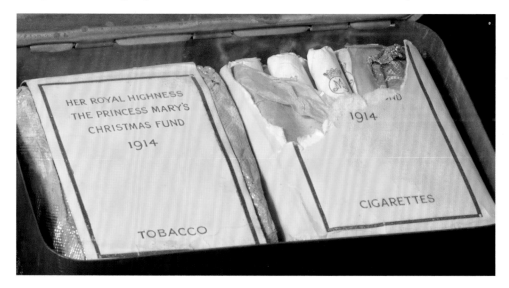

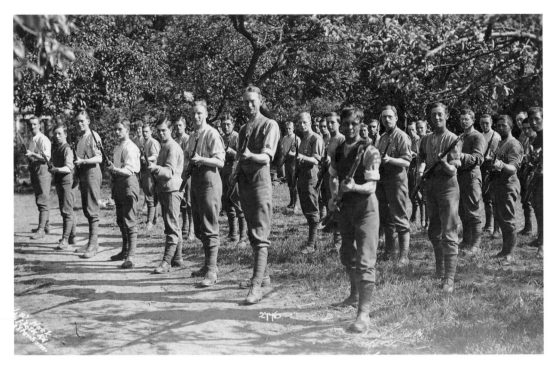

As new battalions were raised, extensive training was required to ensure that the new recruits were adequately prepared for the attritional warfare into which they would be sent. Pictured here are part of the 2nd/5th Battalion undergoing bayonet drills in Chelmsford prior to deployment to the front lines. One of the men was Ivor Gurney, who would gain fame as a poet and composer and is remembered as one of the sixteen First World War poets commemorated in Poets' Corner in Westminster Abbey. Gurney started writing poetry while serving in the trenches and was gassed in 1917.

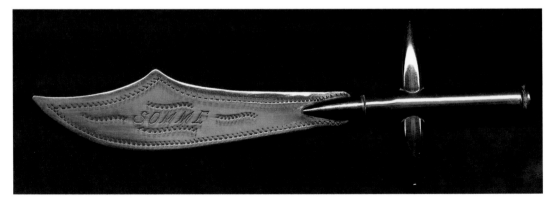

While life in the trenches was clearly very dangerous, it was often dull and monotonous, particularly in 'quiet' sectors. As a result, soldiers would seek to occupy themselves in different ways. Some were prolific letter writers, some kept detailed journals, others wrote poetry or sketched. Some would make decorative items using material around them. An example of trench art is pictured here, where Sgt Lionel Mallard of the 1st/5th turned bullets and shell casings into a brass paper knife, and then engraved the name of his location – 'Somme'.

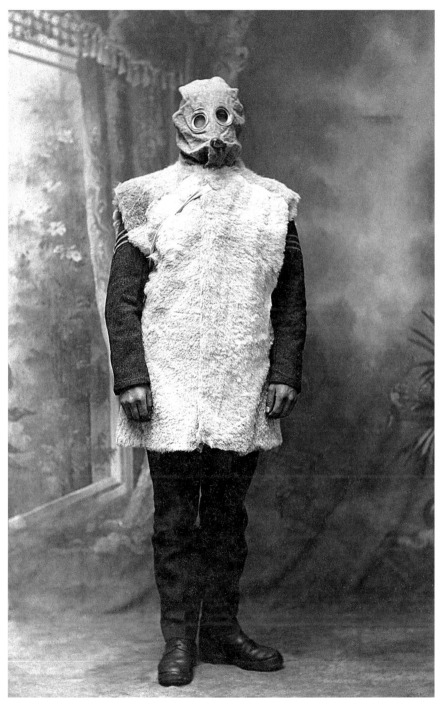

The development of poison gas, initially chlorine gas and then mustard gas, and its use on the battlefield was one of the more unpleasant aspects of the First World War. The British Army had a very rudimentary protection system for gas attacks, consisting of a gas mask and goat-skin jerkin. The impact of a gas attack is best described in Wilfred Owen's iconic poetry, and it would be a constant threat on the Western Front.

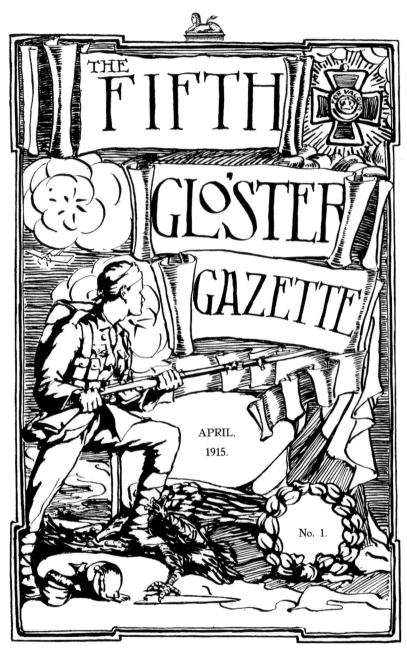

The Fifth Glo'ster Gazette was 'a chronicle, serious and humorous, of the Battalion while serving with the British Expeditionary Force' and was written and published from the front lines by the men of the 1st/5th Battalion. It was the earliest of the trench journals and the first issue was published in April 1915. It would eventually run to twenty-five issues and featured jokes, poetry, news, short stories and satirical adverts. Another of the Gloster's famous war poets, F. W. Harvey, was a founding contributor and published seventy-seven poems in the *Gazette* prior to his capture in August 1916.

PRIVY PURSE OFFICE,
BUCKINGHAM PALACE, S.W.

23rd August, 1915.

Sir,

I am commanded by The King to convey to you an expression of His Majesty's appreciation of the patriotic spirit which has prompted your six sons to give their services at the present time to the Army.

The King was much gratified to hear of the manner in which they have so readily responded to the call of their Sovereign and their country, and I am to express to you and to them His Majesty's congratulations on having contributed in so full a measure to the great cause for which all the people of the British Empire are so bravely fighting.

I have the honour to be,

Sir,

Your obedient Servant,

Wm Ponsonby

Keeper of the Privy Purse.

Mr Charles Dyde.

The pressure for more and more men to join the fight was relentless and would have significant consequences for many families, who would see multiple members join up and go to the trenches. Shown here is a letter from the Privy Purse Office of George V to Charles Dyde. In the letter, the Keeper of the Privy Purse extends the grateful thanks of the King to Mr Dyde for the 'patriotic spirit' that had seen six sons of Mr Dyde join up.

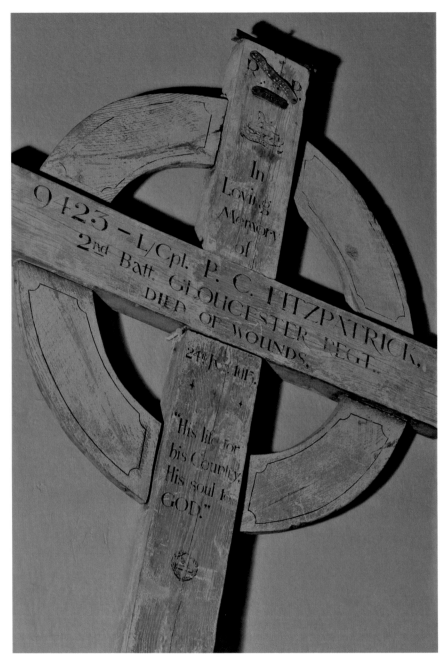

As the war progressed, the trench lines developed and a war of attrition developed, the number of casualties increased significantly. Artillery bombardments and barrages of gunfire lasted for days and weeks, there was a constant risk of snipers and any attack generally necessitated picking your way through a hail of machine-gun bullets only to get stopped by an impenetrable mass of barbed wire. Casualty numbers were astronomical. Efforts were made to mark the graves of the fallen, where they were known, often with wooden grave crosses. However, this was not always possible and thousands of soldiers would end up with no known grave.

The war was not limited to the Western Front of Belgium and France. The 7th Battalion of the Gloucestershire Regiment and the Royal Gloucestershire Hussars were both deployed to the campaign at Gallipoli. Pictured here is the handwritten Operation Order No. 1 for the RGH attack at Suvla Bay. The RGH alternated between the front and reserve lines in Gallipoli for two months, during which time the regiment's strength fell from 300 to just 85. The 7th Gloucesters had fought at Chunuk Bair and had gone into action over 1,000 strong. By the end of the day over 800 had been killed or wounded.

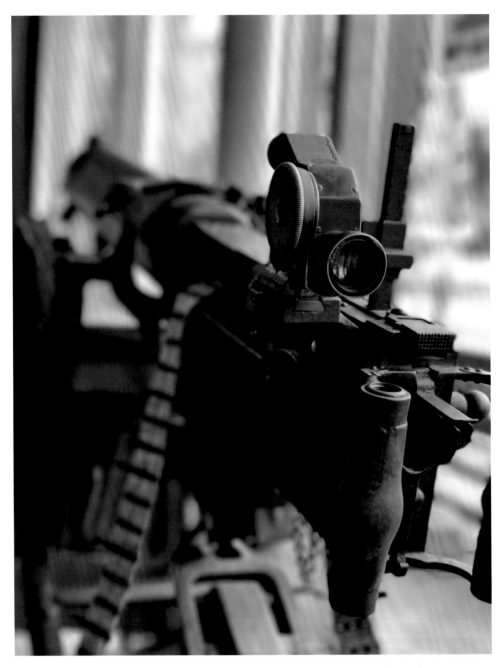

One of the weapons most responsible for the huge casualties was the machine gun. The development of a weapon capable of high rates of fire and mechanical loading began with the Gatling guns used in the American Civil War. By the time of the First World War, these had been developed and finessed by Maxim and Vickers and were capable of firing 600 rounds per minute for hours at a time. Positioned all along the front lines, these would prove to be a very challenging obstacle to any attack. Pictured here is an example of a German Maxim, captured by the 2nd Gloucesters in Salonika in 1917.

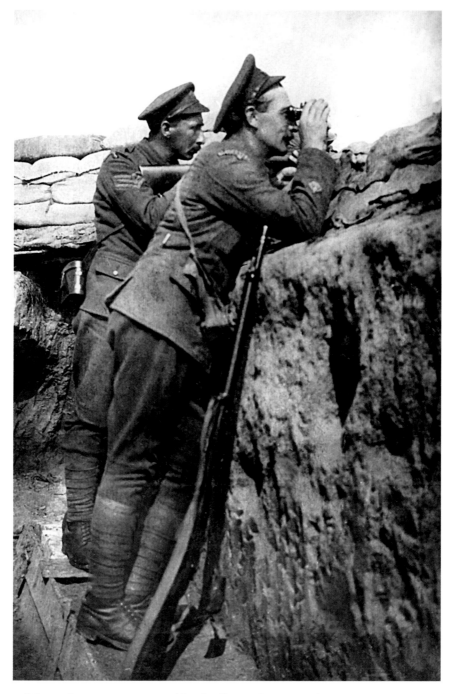

While machine guns were capable of inflicting huge casualties to any mass attack, and were used to fire indiscriminately into enemy trenches, it was snipers that often unsettled units on front-line duty. Snipers would constantly watch the enemy positions, searching for an opportunity to attack a careless soldier who didn't keep under cover. The photograph shows a sniper of the 1st/4th Battalion, being assisted by C. S. M. Bizley looking from the British trench across no man's land in 1915.

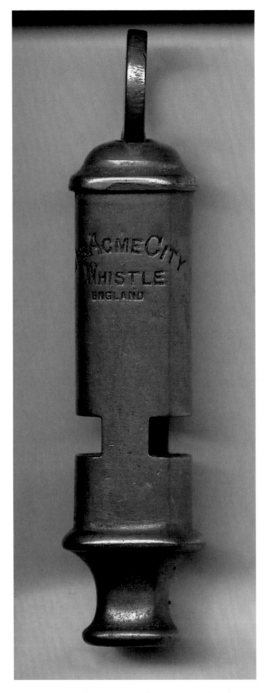

'Going over the top'. Any attack required the men to clamber out of the trenches, through the wire, across No Man's Land, through the enemy wire and into the enemy trenches; all under fire and with huge risks. Attacks at places like Ypres, the Somme, Loos and countless others would see hundreds of thousands die and millions injured. The launch of the attack would be signalled with the simple act of blowing a whistle at the appointed time. One such whistle can be seen here.

DEAR TOMMY,

THANKS FOR THE LOAN OF THIS GROUND, IT SERVED ITS PURPOSE. NOW YOU ARE WELCOME TO HAVE IT BACK.

FRITZ

The Battle of the Somme began on 1 July 1916 and is remembered as one of the bloodiest battles in history. Over three million men fought in the battle, with over one million killed or wounded. A number of battalions of the Gloucestershire Regiment took part in the various stages of the battle, which resulted in limited gains. Pictured here is a German propaganda leaflet that had been left pinned to a tree in High Wood, the scene of one of the Gloucester's attacks in late July.

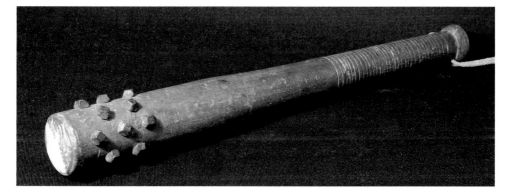

While weapons had become more sophisticated, artillery more precise and aeroplanes were coming into action for the first time, there was still a rather primitive element to some of the weaponry used in the First World War. The weapon of last resort, if an attack had got past the machine guns, barbed wire, rifles, handguns and bayonets, was a simple club. Pictured is a German wooden trench club, studded with iron studs, ready to be used in a dire emergency.

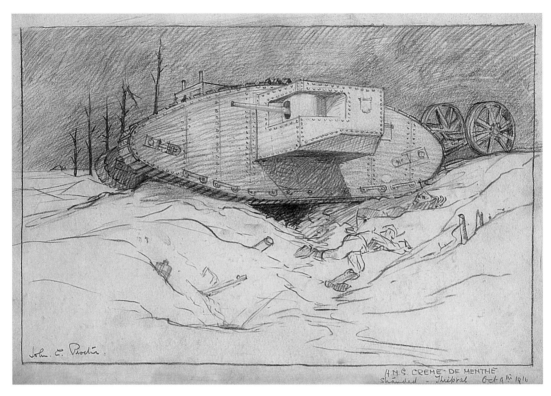

H.M.S. CREME DE MENTHE
Stranded - Thiepval - Oct 9th 1916

Above and opposite: Skilled artists have long been part of any regiment – as seen in India – and the First World War was no exception. The 13th Battalion contained an officer who produced a series of memorable sketches and drawings detailing his view from the trenches, two of which can be seen here. Capt. J. C. Procter MC was Adjutant of the Battalion and stationed in the trenches of the Somme when these two images were created. The first is one of the earliest known pictures of a tank, which was first used on the Somme, drawn in October 1916. Tanks were classified as 'land battleships', and the first were named after French liquors. HMS *Crème de Menthe* is stranded as it attempted to cross a ditch, but the scale of the new weapon is apparent. The second picture details a small group of wounded soldiers attempting to shelter in a shell hole, waiting for an opportunity to try and get back to the safety of the British lines. Procter's images are incredibly powerful reminders of the horrors faced by troops in the front line.

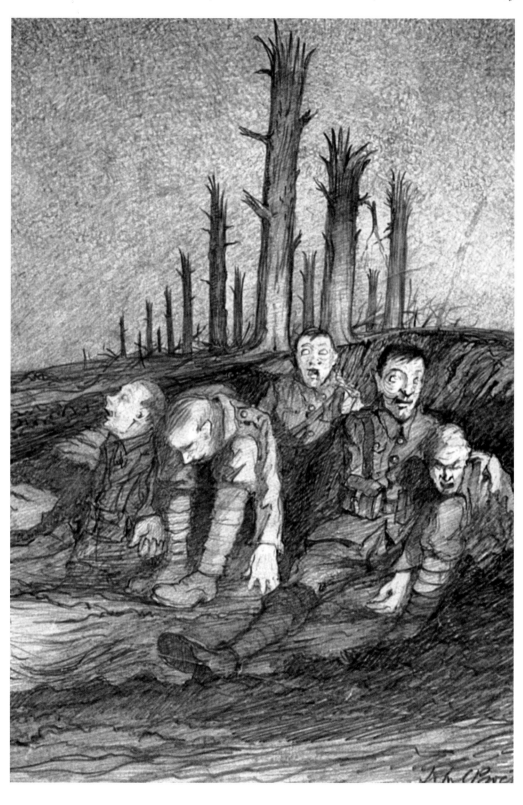

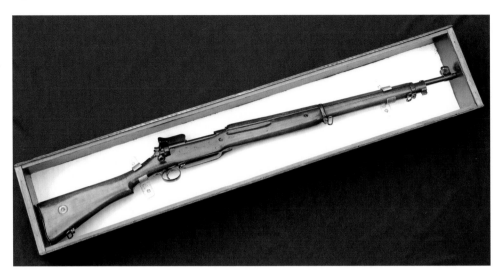

The primary weapon of the British Army was a bolt action, magazine-fed repeating rifle that had first seen service in the Boer War and would remain the standard rifle until 1957. The Lee-Enfield .303 rifle is still found in service in some countries today, a testament to the design and reliability, and it is estimated that seventeen million have been produced. The rifle pictured was used by the Royal Gloucestershire Hussars throughout the war and then preserved in a bespoke wooden case until presented to the museum.

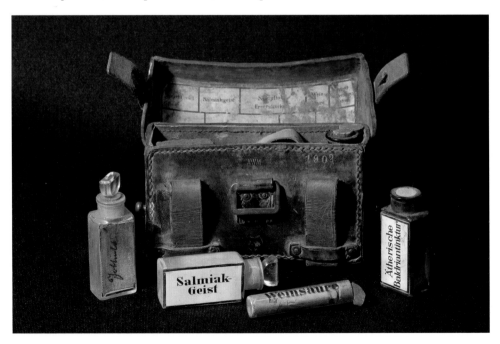

The museum collection houses a large number of objects captured from enemy troops over the years. One of the more unusual is a German first-aid case. This was captured by Capt. Lavender MC of the 1st Battalion at High Wood on the Somme in 1916. The case is very well constructed, sturdy and contains labelled sections for all of the medical items required, including a vial of opium.

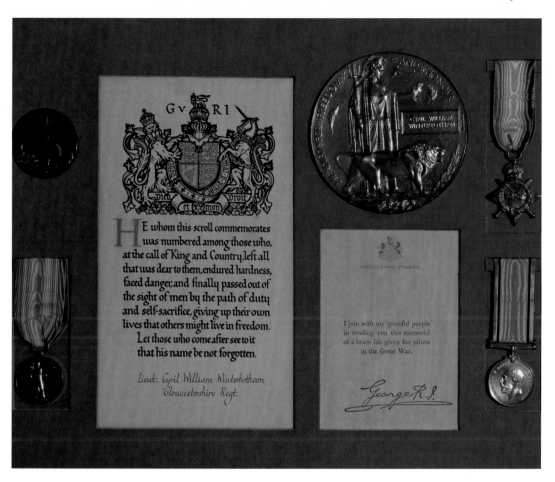

Many families waiting at home would have received the devastating news that a loved one had been killed in action. The next of kin of a deceased soldier would receive a number of items recognising their service and sacrifice and many families would produce memorial frames to honour their memory. One example of this commemorates Lt Cyril Winterbotham of the 1st/5th Battalion. Winterbotham, who had edited *The 5th Glo'ster Gazette*, died in August 1916 and the frame contains his medals, his bronze memorial plaque and the scroll and letter from George V. This frame would be repeated in tens of thousands of households across the country as the casualty numbers continued to rise. By the end of the war, over 8,100 of the Gloucestershire Regiment and 228 Royal Gloucestershire Hussars would lose their lives.

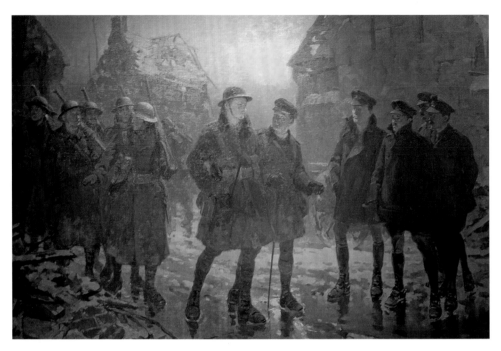

Winterbotham is also remembered in a large oil painting by Frederick Roe. The painting, entitled 'A Relieved Platoon of the 1st/5th Gloucesters at Hebuterne', shows a group of officers in conversation in the small village of Hebuterne, which was occupied by Allied Forces and situated just 800 yards from the German defences at Gommecourt. The officers are Winterbotham, Padre G. F. Helm, Capt. J. P. Winterbotham (brother of Cyril), Major J. H. Collett, Major J. F. Tarrant and Major N. H. Waller.

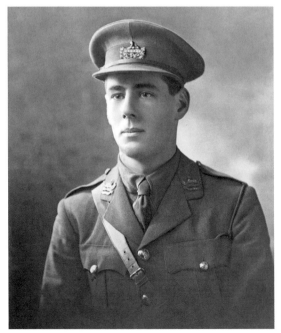

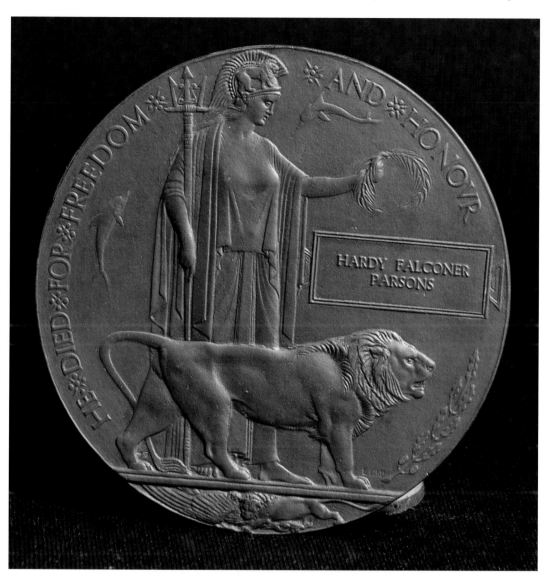

Above and opposite below and overleaf: Another member of the Gloucestershire Regiment to lose his life was 2nd-Lt Hardy Falconer Parsons VC, who was killed in action on 21 August 1917. Parsons was studying in Bristol before the war and was a member of Bristol Officers' Training Corps, and joined the 14th Battalion. The Germans launched a surprise night attack on the section of trench held by Parsons and his men. The men were all forced back, but Parsons remained at his post and 'single-handed and although severely scorched and burnt by liquid fire, he continued to hold up the enemy with bombs until severely wounded'. His citation continues; 'This very gallant act of self-sacrifice and devotion to duty undoubtedly delayed the enemy long enough to allow the organisation of a bombing party, which succeeded in driving back the enemy before they could enter any portion of the trenches.' Parsons succumbed to his wounds but his bravery was recognised with the award of the Victoria Cross, one of five awarded to the Gloucestershire Regiment in the First World War.

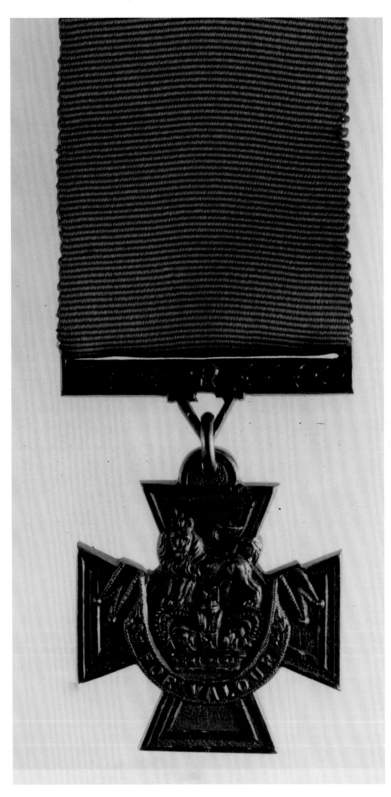

As has been seen, the museum collection houses a number of items seized from the enemy, including this automatic pistol captured by Capt. Dobson MC of the 1st Battalion. One of three pistols taken, this particular model has been fitted with a wooden stock, enabling it to be used as a rifle.

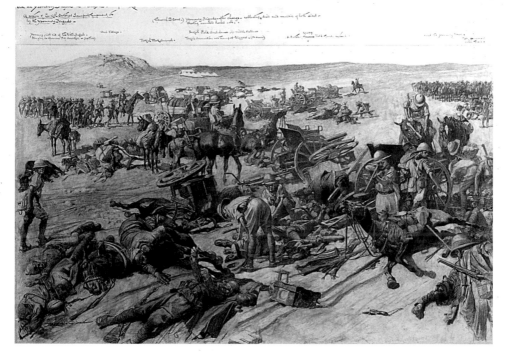

Above and overleaf: Following their actions at Gallipoli, the Royal Gloucestershire Hussars had been fighting across the Sinai and into Palestine. After receiving significant casualties at Qatia in April 1916, the regiment had enjoyed success at Romani before forming part of Allenby's advance through Palestine and beyond. Pictured here is a drawing of the 'Yeomanry Brigade in Palestine', and details numerous activities. These include collecting the dead and wounded, capturing Turkish batteries, transports and equipment, capturing field guns and howitzers, looking after horses and dealing with prisoners of war. Allenby's campaign was a great success and the RGH moved through Palestine and Syria. Following the capture of Kilis, the RGH took over a number of the local functions. The gold ring had belonged to the Turkish postmaster of Kilis and, following its capture, was handed over to Trooper Herbert Collins, who was appointed postmaster during the British occupation.

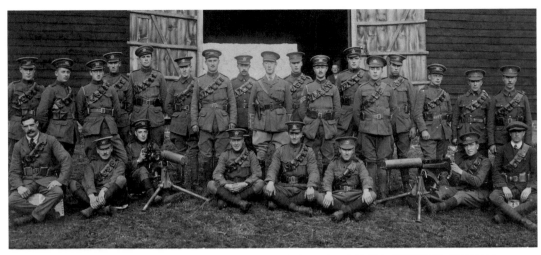

MACHINE GUN SECTION OF THE ROYAL GLOUCESTERSHIRE HUSSARS YEOMANRY

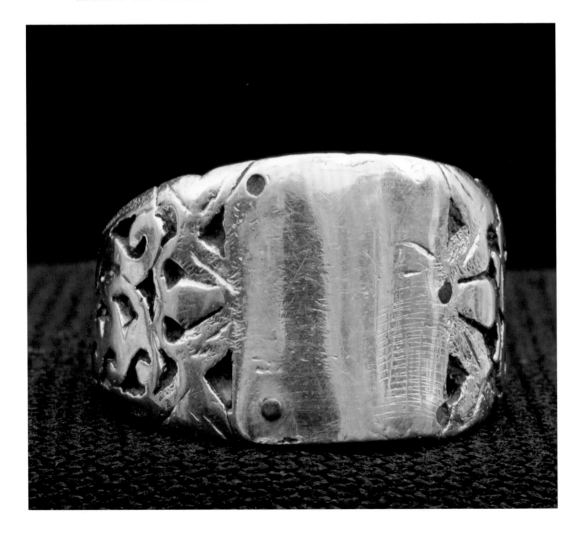

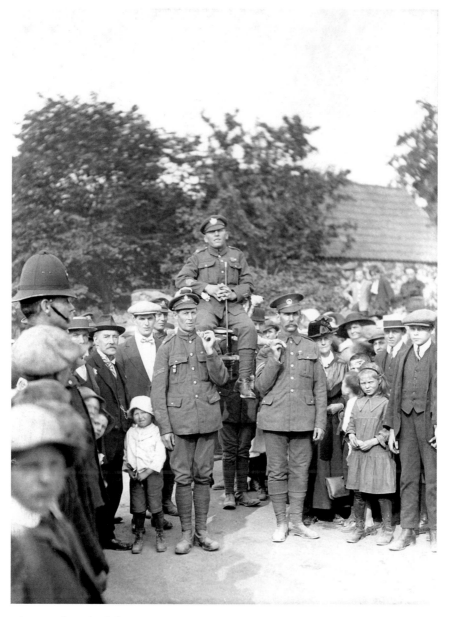

Above and overleaf above: Francis George Miles was a local man, born in Clearwell in 1896. He joined the 1st/5th and in October 1918 was being held up by a line of enemy machine guns. Miles, on his own, rushed forward, and under exceptionally heavy fire located a machine gun, shot the gunner and put it out of action. He then advanced alone again, shot the gunner and rushed the machine gun, capturing the team of eight men. He then signalled to the rest of his unit who, following his signals, were able to capture sixteen machine guns and take over fifty prisoners. Miles was awarded the Victoria Cross, and the photograph shows his return following the end of the war. Miles had been to Buckingham Palace to receive his award and as he returned to Clearwell, the entire village came out to greet him, hoisted him into a chair and carried him through the village. He then returned to work in the mines of the Forest of Dean.

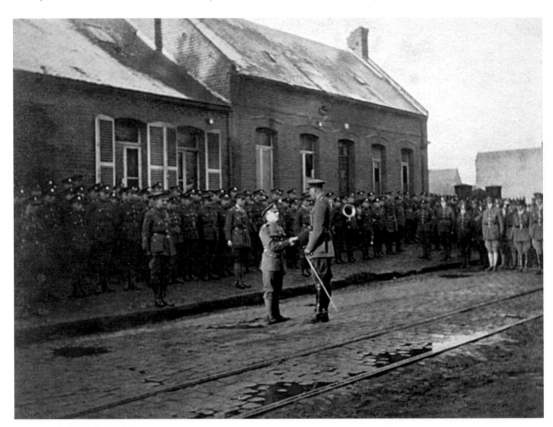

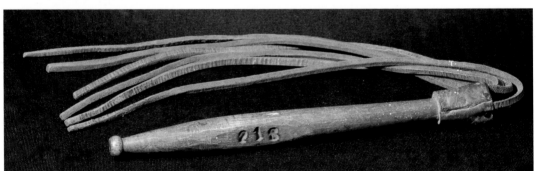

Above and opposite: A significant number of men in the Gloucestershire Regiment were captured by the Germans and would spend the rest of the war in prisoner of war (POW) camps across Germany. These men endured a very difficult time, and this was recognised at the highest level. Pictured is a letter from George V to L/Cpl Alfred Seabright of the 1st/5th following his release from captivity. The King refers specifically to 'the cruelties of their captivity' and is 'thankful that this longed-for day has arrived'. This letter, welcoming him back following the 'miseries and hardships which you have endured with so much patience and courage', is a stark reminder that conditions in the camps could be very unpleasant. An example of this can be seen by cat o' six tails whip, which was retrieved from a POW camp housing British Officers in Cologne. The whip was used against British prisoners in the camp and is clearly responsible for some of the 'cruelties' referred to by George V.

204364 Pte Seabright. A.R.
Gloucester Regt

BUCKINGHAM PALACE

1918.

The Queen joins me in welcoming
you on your release from the
miseries & hardships, which you have
endured with so much patience &
courage.

During these many months of trial,
the early rescue of our gallant Officers
& Men from the cruelties of their captivity
has been uppermost in our thoughts.

We are thankful that this longed
for day has arrived, & that back in
the old Country you will be able
once more to enjoy the happiness of
a home & to see good days among
those who anxiously look for your
return.

George R.I.

——THE——

DISABLED OFFICER'S HANDBOOK

January———1919

ARMY AND ROYAL AIR FORCE

MINISTRY OF PENSIONS

Once the war had ended, and work began on recovering and rebuilding, it was necessary to make significant adjustments to the way people lived. Pictured is a Disabled Officer's Handbook, issued in January 1919. Officers and soldiers were suffering from a wide range of disabilities, both physically and mentally. Some had lost limbs, others their sight or hearing, some were suffering the permanent effects of poison gas and others from 'shell shock'. It was necessary to provide advice and guidance to these men, and while it wouldn't be acceptable in the modern era, it was an early attempt at providing advice to allow these men to adapt to the lives they now faced.

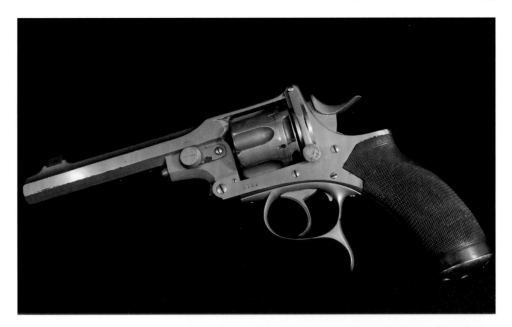

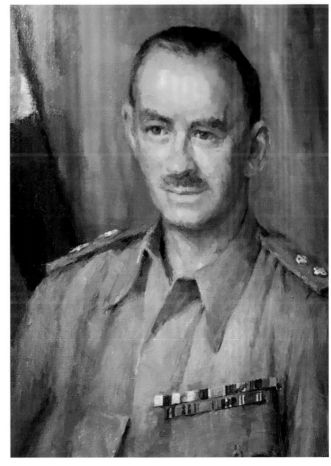

Above and right: Weapons remained relatively unchanged in the first half of the twentieth century, and many would see use in both world wars. An example of this is the Webley .45 revolver, used by officers in both conflicts. This particular firearm was used by C. E. K. Bagot, who served in the First World War and was commanding the 1st Battalion at the outbreak of the Second. Following the Japanese invasion of Burma, he led the regiment as the Burma army was forced to withdraw. Despite being in almost daily contact with the enemy, they successfully held the Japanese at bay throughout a 600-mile retreat, with the loss of eight officers and 156 men.

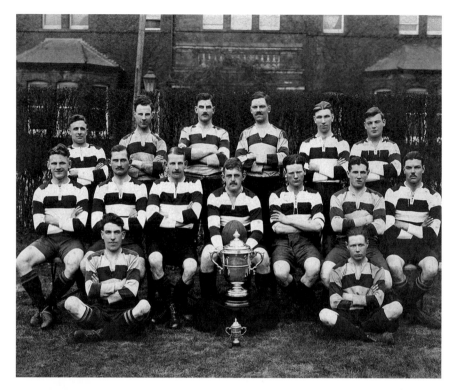

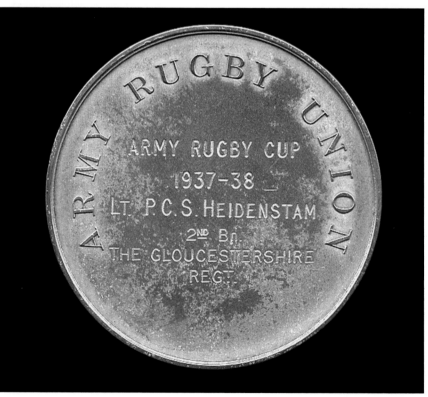

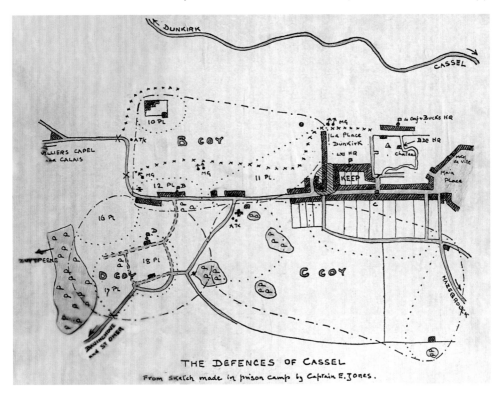

THE DEFENCES OF CASSEL

From sketch made in prison camp by Captain E. Jones.

Above: While the 1st Battalion were in the Far East, both the 2nd and 5th Battalions formed part of the British Expeditionary Force in France. As the Germans advanced rapidly, a plan was formed to evacuate the British Army from the beaches of Dunkirk. The 2nd and 5th were tasked with forming part of a defensive screen south of the beaches to delay the Germans. With the 5th based around Ledringhem, the 2nd took up positions defending Cassel, as can be seen in the hand-drawn plan, and fought with great bravery and determination for four days. When the order to withdraw finally came, the 5th were able to extricate themselves but the 2nd were surrounded and it was too late to escape. One hundred and thirty-seven men were killed, fifty-seven wounded and virtually every other man was taken prisoner.

Opposite: Following the war, the new battalions were disbanded, the Territorials reduced in size and the Regulars, the 1st and 2nd, were posted almost at once to India and Ireland. Regular movement continued and life returned to pre-war normality. Sport was a major part of regimental life and the museum houses numerous trophies and medals from a wide range of sports. Rugby has always played a big role, as it does in the county itself, and the 1st Battalion team of 1925/26, seen here, enjoyed a successful season, winning the Aldershot Cup. The team is unique as it contains two men who were, or would become, recipients of the Victoria Cross. The captain of the team, seated in the centre with the ball, was Manley Angel James, who won the VC in April 1918. Standing immediately behind and to the right of James is a young 2nd-Lt, James Power Carne, who would win the VC in Korea a quarter of a century later. It wasn't only the team of the 1st Battalion who enjoyed success on the rugby field. This medal was awarded to Lt P. C. S. Heidenstam of the 2nd Battalion following their victory in the Army Rugby Cup in 1937/38.

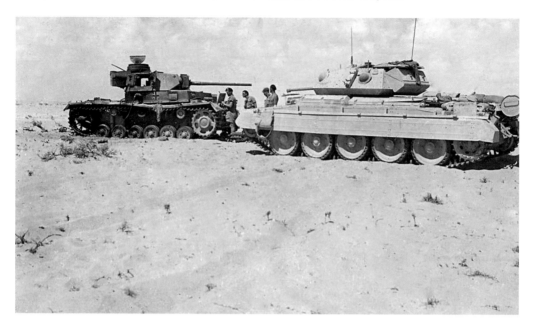

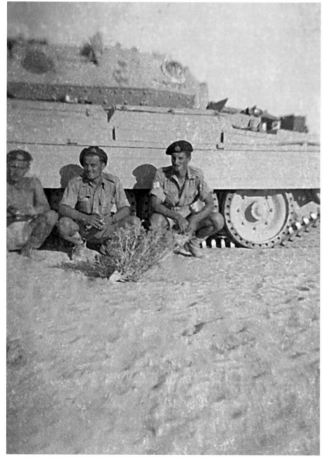

Above, left and opposite:
With the Gloucestershire
Regiment fighting in Europe
and the Far East, the Royal
Gloucestershire Hussars
embarked for Egypt in
1941 to form part of the
Eighth Army. This series
of photographs shows the
men of 2RGH during the
campaign against Rommel.
The campaign saw the RGH
distinguishing itself on
numerous occasions, although
it suffered heavy casualties in
the process. During a series
of actions south of Tobruk in
June 1942, the Commanding
Officer, Second in Command
and Adjutant were all killed,
and a number of men were
captured. A few of the
prisoners would spend the
rest of the war in Auschwitz.
The men of the RGH added
ten Battle Honours to the
Regimental Guidon during
this period.

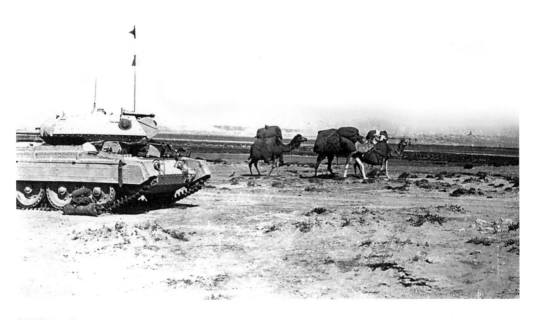

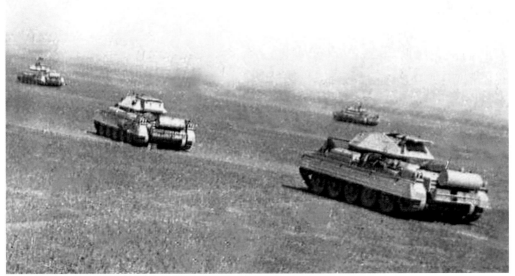

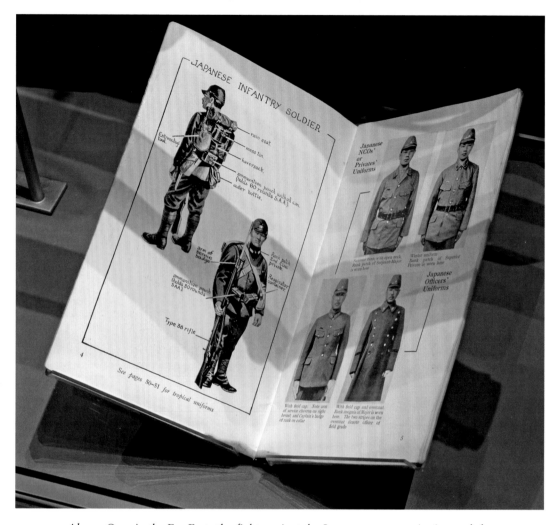

Above: Over in the Far East, the fight against the Japanese was continuing and the newly formed 10th Battalion would be at the centre of this. Prior to their deployment, the men of the 10th were provided with a pamphlet on the Japanese Army. The 10th landed at Myitkyina near the China–Burma border and joined the 36th Division. They spent the next ten months moving south, living and fighting in the jungle, covering over 700 miles.

Opposite: The 2nd Battalion were reformed following the losses at Cassel, and on 6 June 1944 landed on the beaches of Normandy on D-Day. Shown here is the transcript of the message sent by the Supreme Commander, Allied Forces, General Eisenhower, in advance of the landings. After landing without great loss, the 2nd advanced through France and was largely responsible for the capture of Le Havre. It would continue to move forward through France and into Belgium and Holland by the end of the year.

SUPREME HEADQUARTERS
ALLIED EXPEDITIONARY FORCE

Soldiers, Sailors and Airmen of the Allied Expeditionary Force!

You are about to embark upon the Great Crusade, toward which we have striven these many months. The eyes of the world are upon you. The hopes and prayers of liberty-loving people everywhere march with you. In company with our brave Allies and brothers-in-arms on other Fronts, you will bring about the destruction of the German war machine, the elimination of Nazi tyranny over the oppressed peoples of Europe, and security for ourselves in a free world.

Your task will not be an easy one. Your enemy is well trained, well equipped and battle-hardened. He will fight savagely.

But this is the year 1944! Much has happened since the Nazi triumphs of 1940-41. The United Nations have inflicted upon the Germans great defeats, in open battle, man-to-man. Our air offensive has seriously reduced their strength in the air and their capacity to wage war on the ground. Our Home Fronts have given us an overwhelming superiority in weapons and munitions of war, and placed at our disposal great reserves of trained fighting men. The tide has turned! The free men of the world are marching together to Victory!

I have full confidence in your courage, devotion to duty and skill in battle. We will accept nothing less than full Victory!

Good Luck! And let us all beseech the blessing of Almighty God upon this great and noble undertaking.

Dwight Eisenhower

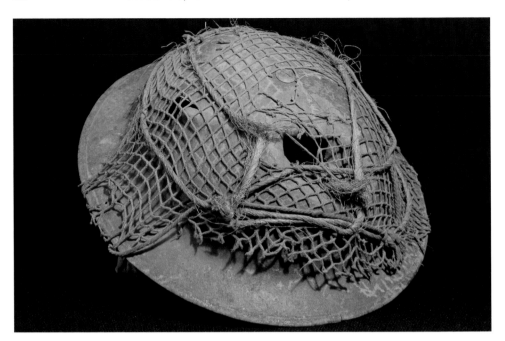

Above, below and opposite: Back in Europe, the 2nd Battalion were continuing their march westwards. During the advance towards Caen, Private Norman Taylor was hit, with a bullet entering his helmet, creasing the top of his head and exiting the other side of the helmet. The helmet clearly shows how fortunate Taylor was to only have to spend 'a couple of days in hospital'. The advance was relentless and by April 1945 the battalion were in the lead during the assault crossing of the River Issel to capture Arnhem (pictured). Three weeks later the remaining German forces surrendered and the 2nd Battalion moved through Germany to Berlin. The end of the war saw inevitable changes to the Armed Forces and in 1948 the two battalions of the Gloucestershire Regiment were reduced to a single unit.

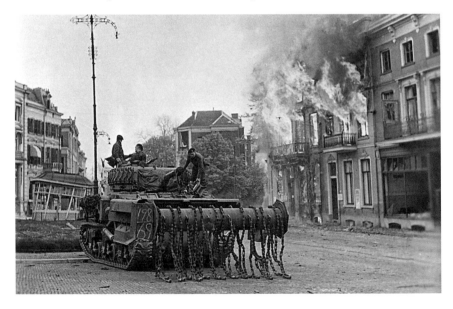

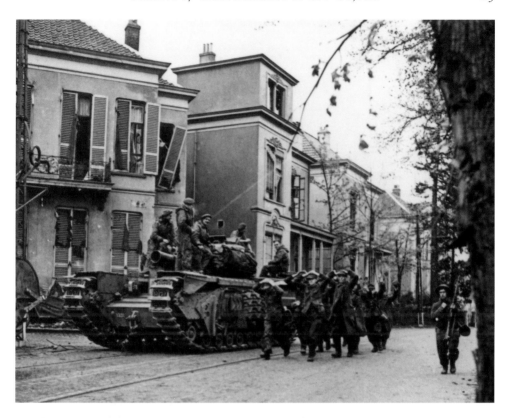

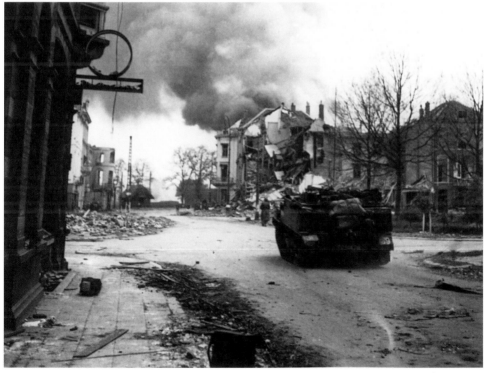

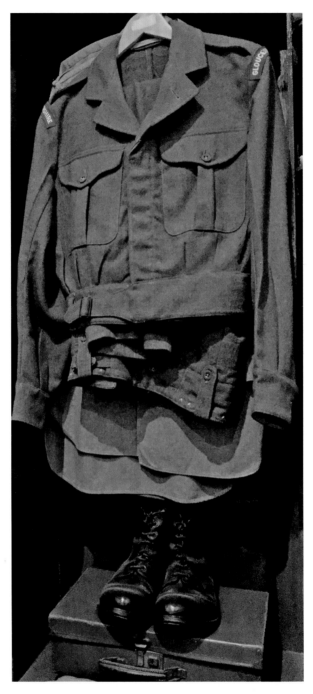

Above and opposite above: Following the end of the Second World War, a debate took place about the role of conscription into the Armed Forces. In 1948, the National Service Act was passed, requiring all healthy males aged between seventeen and twenty-one to serve for eighteen months and remain on the reserve list for a further four years. This would be extended to two years in 1950 as a result of the Korean War. Pictured is the uniform issued to a National Serviceman in the Gloucestershire Regiment.

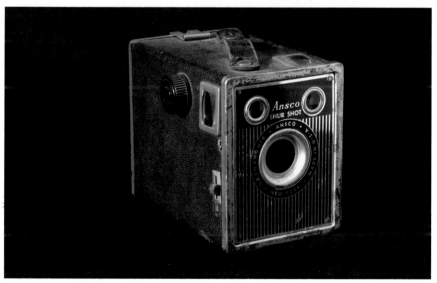

In 1950, war broke out on the Korean Peninsula and the Gloucestershire Regiment were sent to Korea as part of the United Nations forces tasked with repelling the North Korean invasion. A significant number of the men serving were completing their National Service, and the Glosters would play a hugely significant role in the conflict. One of those men was a young private called Sam Mercer, whose belongings included an Ansco Shur-Shot Box Camera. Cameras had become an increasingly common addition to a kitbag, with the result of providing a more complete visual record of the activities of a regiment.

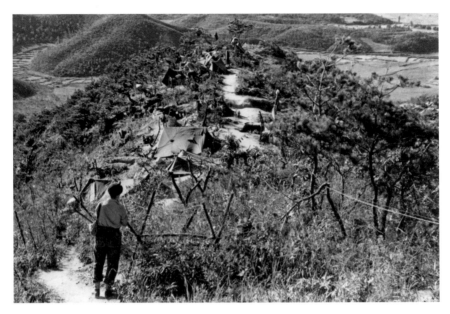

Above, below and opposite: In April 1951, the Gloucestershire Regiment were positioned to the south of the Imjin River, on the summit of Hill 235. On the night of 22 April 1951, the Chinese army launched a massive assault across the Imjin and the Glosters were heavily attacked. The Chinese were repulsed with heavy casualties, but the attacks continued relentlessly throughout the 23rd and 24th. The regiment was commanded by Lt-Col. J. P. Carne, pictured here prior to the battle, and he would show a complete disregard for his own safety through the battle. The battalion was continuously assaulted and by 25 April were completely cut off from the rest of the brigade. Carne moved amongst his men, under heavy mortar and machine-gun fire, and on two separate occasions personally led assault parties to drive back the enemy. The Chinese attacks were announced by bugle call, and each call would signal a new attack. There were innumerable acts of bravery and heroism throughout the battle, including the exploits of Lt Philip Curtis, who would be awarded a posthumous Victoria Cross, and these are better described in other publications. The actions of the Glosters, and the other battalions with the brigade, delayed the Chinese for four vital days and blunted their attack significantly. Less than seventy members of the regiment managed to extricate themselves and the remainder were either killed or captured. For the majority, this meant the next two years as POW's although some, such as Terence Waters, would not make it home. Waters was awarded a posthumous George Cross for his courage in the camps. As a permanent legacy to the bravery shown, Hill 235 was renamed Gloster Hill by the South Korean people.

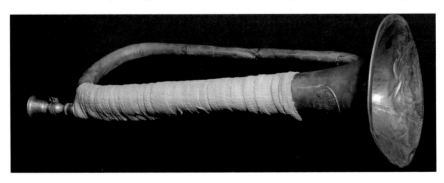

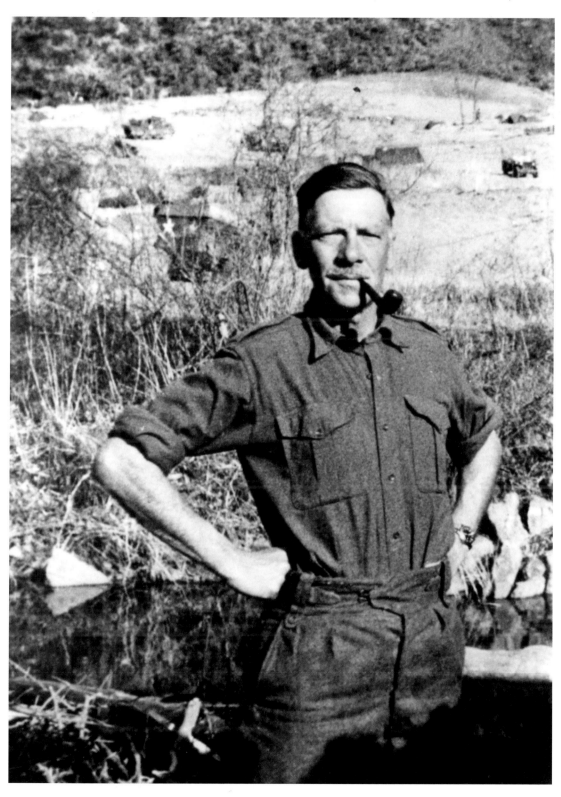

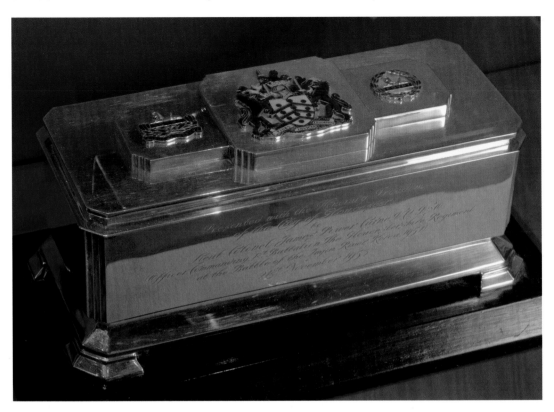

Above and opposite: There were many awards and honours that followed the incredible bravery shown on the banks of the Imjin River, particularly to the Commanding Officer. James Power Carne was awarded the Freedom of the City of Gloucester on his release from captivity, only the seventh person in history to receive the honour. The Scroll was contained in a bespoke silver casket (pictured here) featuring the Coat of Arms of the City and the Regimental Badges. He was also awarded the Victoria Cross for demonstrating 'powers of leadership which can seldom have passed in the history of our Army'. He 'inspired his officers and men to fight beyond the normal limits of human endurance'. His bravery was recognised by the United States with the very unusual award of the Distinguished Service Cross, for which permission had to be sought from the Queen for it be worn. The United States also recognised the bravery of the entire regiment with an award unique to the Glosters. The Presidential Unit Citation is awarded to signify acts of extraordinary heroism in action, above and beyond what can be reasonably expected, setting it apart from other units participating in the same campaign. The Gloucestershire Regiment received this honour, the only regiment in the British Army ever to do so, which took the form of a blue streamer emblazoned with the name of the battle to be attached to the Regimental Colours (pictured), and a small blue and gold ribbon worn on the uniform. The Presidential Unit Citation would join the Back Badge as unique symbols of the bravery and courage shown by members of the regiment.

CITY OF GLOUCESTER

At a Special Meeting of the Council of the City of
Gloucester, held at the Guildhall, in the said City,
on Friday, the 30th. day of October 1953.
Present: Alderman A.G. Lea, Mayor, in the Chair.
On the motion of the Mayor, Seconded by Councillor W.J. Smith (Deputy Mayor)
IT WAS UNANIMOUSLY RESOLVED AND ORDERED
That, in pursuance of Section 259 of the Local Government Act, 1933, this Council do confer upon
Lieutenant Colonel JAMES POWER CARNE, v.c., d.s.o.
as Commanding Officer of the 1st. Battalion, The Gloucestershire Regiment at the time of the Battle of the Imjin River, Korea, in April, 1951.
THE HONORARY FREEDOM OF THE CITY OF GLOUCESTER
in recognition of the gallantry and courage displayed by the Battalion in this engagement, and of Colonel Carne's own personal valour in the
battle when, as stated in the Citation accompanying the award of the Victoria Cross to him, he showed powers of leadership which can
seldom have been surpassed in the history of the British Army, and inspired his officers and men to fight beyond the normal limits of human
endurance, in spite of overwhelming odds and ever-increasing casualties, shortage of ammunition and of water.
And Lieutenant Colonel James Power Carne is accordingly admitted an Honorary Freeman of the said City.

Mayor
City High Sheriff
Town Clerk

The said Lieutenant Colonel James Power Carne took the Freeman's Oath and signed the Roll of
Honorary Freemen at the Guildhall, in the said City, on the Twentyfirst day of November 1953

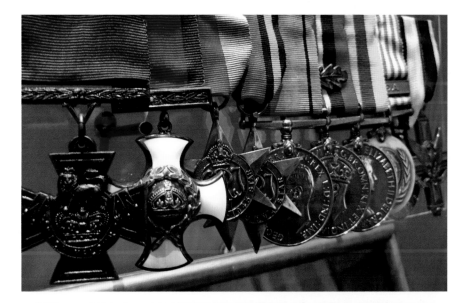

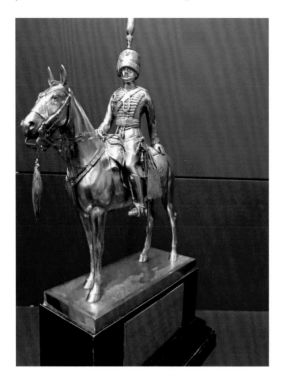

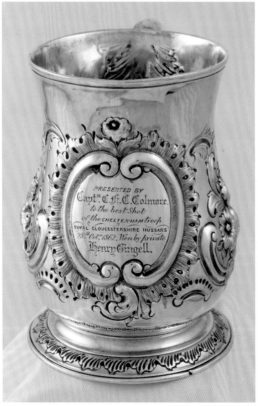

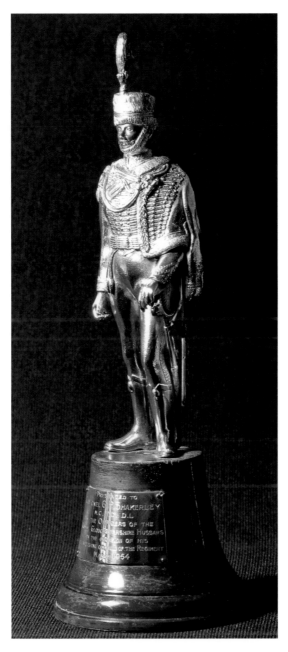

Above and left: Throughout the centuries, significant occasions or events within a regiment were often marked with the commissioning of a piece of silver. While the post-war period saw significant change, this tradition was maintained. The Officers of the Royal Gloucestershire Hussars commissioned a beautiful statuette of an RGH officer in full dress and presented it to Col G. P. Shakerly MC as he relinquished command of the regiment in March 1954. There are many pieces of silver in our collection, such as the Shooting Cup dating from 1862 and the Mounted Officer of the RGH, presented to Lt Col Turner on the occasion of his wedding in 1929.

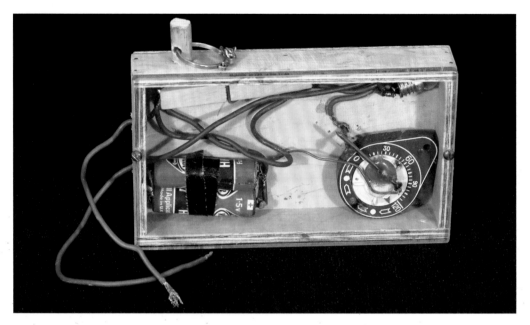

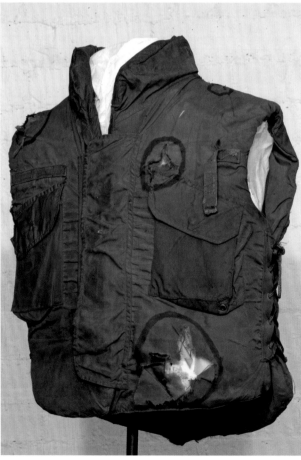

Above, left and opposite: Following the Korean War, the Gloucestershire Regiment began a series of operational roles around the world, including Kenya, Cyprus, Aden and others. It spent a considerable amount of time in Germany and was in Northern Ireland throughout the Troubles. Pictured here is a good example of the changing nature of the threats being faced by the regiment as conflict moved from set-piece battles to anti-terror operations. This home-made detonator device, made by terrorists and captured in 1972, shows the dangers faced during this period, as does the green flak jacket. Lt T. G. Ongley was patrolling the Lower Falls area of Belfast in 1973 when he was attacked. The torn areas in the jacket were caused by five bullets which caused serious wounds to his arms and chest. The nature of conflict had changed significantly, as would be seen in future operations in Iraq and Afghanistan.

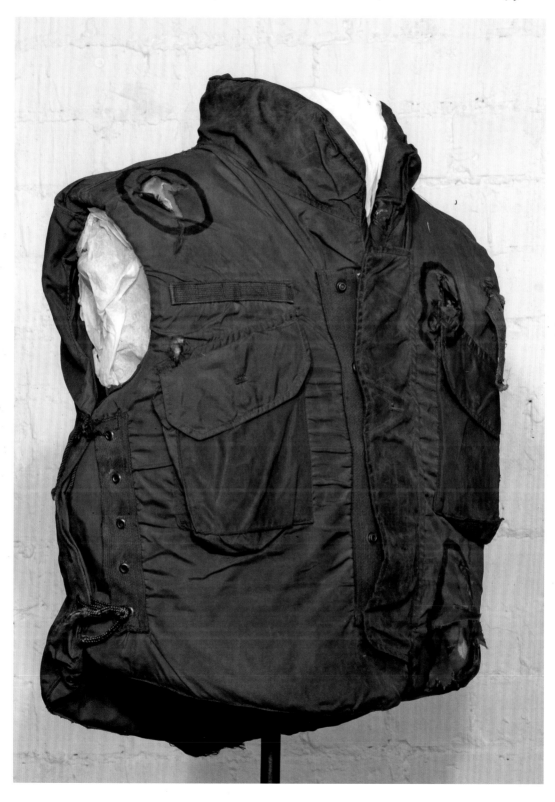

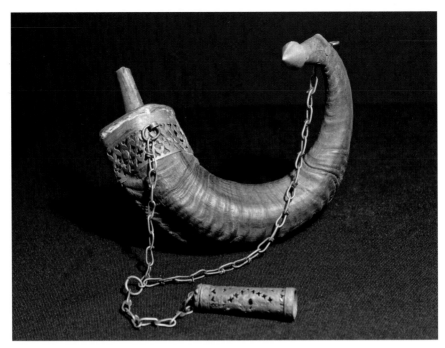

In 1994, the Gloucestershire Regiment celebrated its tercentenary with a series of parades throughout the country. Later in the year, following significant changes to the Armed Forces, it was amalgamated with the Duke of Edinburgh's Royal Regiment to form the Royal Gloucestershire, Berkshire and Wiltshire Regiment. Despite the name change, the soldiers of the regiment would continue to distinguish themselves on operations, such as the deployment to Afghanistan as part of Operation Herrick. This Afghan powder horn was captured in 2005 and is reminiscent of the powder horns used two centuries earlier by the men of the 28th and 61st.